The
Live Art
Almanac

A Live Art UK initiative, published by the Live Art Development Agency
and financially assisted by the University of Leeds

The Live Art Almanac

Contents

The Live Art Almanac

Welcome to The Live Art Almanac, a collection of writing about and around Live Art. The Live Art Almanac brings together texts which are representative of the most engaging, provocative, thoughtful writing about Live Art and the cultural landscape in which it is set, and which were first published between April 2006 and April 2008.

The Live Art Almanac is an initiative of Live Art UK, a consortium of venues, promoters and facilitators which explores new models and partnerships for the promotion of Live Art; develops new ways to increase the national and international visibility of Live Art; and initiates strategies for a more sustainable future for Live Art practitioners and promoters. The Live Art Development Agency is a member of Live Art UK and has led the development and delivery of The Live Art Almanac as part of its contribution to the activities of Live Art UK.

Between April 2006 and April 2008 Live Art UK delivered *Into Action*, a programme of activity which included touring commissions, networking events, and a critical writing scheme. The Live Art Almanac is one part of the critical writing initiative through which we have sought to support accessible critical writing on Live Art.

Writing From Live Art, the Live Art UK critical writing initiative has been one of the successes of *Into Action*. Lead by Joshua Sofaer, the initiative has enabled eight writers new to Live Art to undertake workshops and tailored mentoring, and to attend performances and events. The writers published their work in a broad range of publications whilst on the scheme including national visual art and theatre journals. The writers also established www.writingfromliveart.co.uk, the Writing From Live Art website which includes much of their work written during the scheme. We are particularly pleased that Rachel Lois Clapham and Mary Paterson have subsequently gone on to establish Open Dialogues – www.opendialogues.com. Texts by a number of the *Writing From Live Art* writers are included in the Almanac.

The material for The Live Art Almanac was gathered through recommendations. In early 2006 an open call announced:

What articles have you read, what emails did you receive or forward to a friend, what blogs have you visited, what texts crossed your path? Did they engage you, amuse you, or make you rethink Live Art? If it caught your eye and had something interesting to say then we want to know about it. Live Art addresses a broad range of audiences and we are seeking contributions that reflect these audiences in the range of writing styles and where the writing is placed.

Over the next two years the submitted recommendations included a range of forms from newspaper and journal articles, through blogs and websites, to transcripts of presentations and dialogues. We received many more recommendations than we could publish and have made a selection which reflects this diversity of forms, and addresses a range of subjects and topics. In particular, we have tried to make a selection which sheds light on Live Art and its discourses. There are, of course, texts about individual artists and projects but the Almanac is not intended to be a survey of practices and these articles have been included for what they say about the interests of the sector as much as their focus on any one artist. Without setting out to, the Almanac also reflects some of the major events to take place over the two years including the Pacitti Company's first SPILL Festival and the publication of Manuel Vason's *Encounters* published by Arnolfini, as well as annual events such as the National Review of Live Art and Fierce! Festival.

When we set out we had (possibly naively) imagined collecting an inbox of press clippings, photocopies and hand written notes which we would assemble – quite literally – into the Almanac. But very early on, as the recommendations came in –

almost all via email with directly links to online material – it was clear that the cut and paste would be on a computer screen rather than with paper, scissors and glue.

Our approach to editing has been to be as hands-off as possible and the majority of texts are reproduced in the Almanac as they were originally published. We have laid the texts out using a standard format but have not imposed a house style.

While we've not edited the content of the texts we have given them a loose order. As you read you will find a number of recurring themes either running through the Almanac or gathered in small groupings. Included are letters, a focus on walking and travel, and dialogues.

The Almanac has only been possible through the interest and engagement of all the people who have made recommendations over the last two years. To them we are extremely grateful. We'd also like to thank the writers and publishers who have been so generous with their permissions to reproduce their work. Thanks are also due to Philip Stanier who was involved early on in the project and hosted the first critical writing workshop at Leeds University. *Into Action* has been supported by Arts Council England and The Live Art Almanac has been financially assisted by the University of Leeds.

We hope you enjoy reading The Live Art Almanac.

Daniel Brine, editor, Live Art Development Agency
Emmy Minton, managing editor, Live Art UK
May 2008

Step Off The Stage

Tim Etchells

Mark E Smith. Ajanta Cinema Derby, sometime in 1977 or 1978, back at the time when he was talking at least as much as singing, punctuating the songs with extended delirious rants about the proliferation of psychics and Cash & Carry stores or the possibility of time travel or how much he did not like Doncaster or the audience or Stalin you could never be sure which. Huge fucking row of music, small audience. A venue that used to be, by some incomprehensible irony, *The Derby Playhouse* (I mean before they built that new one with hexagonal barstools and purple orange cross-hatch carpets) and was by then (the old playhouse, re-named as *Ajanta Cinema*), a semi-derelict music venue run by some Asian guys maybe as a front for a drugs ring at least if you believed what was gonna be in the paper ten months later, who knows.

Just in front of the stage there is a space that used to be seats, but which has been for some months now an extended no-mans land, a zone of smashed floorboards and seat-remains – a cleared space created when the first gig took place here and at which the room allowed for the crowd was patently not big enough and so by Mutual Agreement the seats were kicked to pieces by those present, the debris for the most part lifted high and Hurled Asunder, causing minor injuries. It is this space – directly to the front of the stage that Smith has his eyes on, when he turns around, neglecting the routine that he himself has characterised as 'backs to the audience and pass the hair-dye mate' though he of course has no hair dye. This space, right there in front of the stage, this no mans land, is clearly bothering him, big time. Maybe cos there's no one in it – I mean there's only fifty people in the venue max and most of them are leant against the walls holding lager cans. And maybe it's bugging him – this space – cos he's not sure who's it is. I mean – he's on the stage and he's wandering all around it like he owns the fucking place, which for all extents and purposes he does – but somehow he doesn't seem so happy there on the stage – like he'd really like to be somewhere else, in some other place, a bigger one perhaps. Like somehow the stage is too small because it isn't a whole world.

What does the character Price say about the nightclub in Trevor Griffith's play *Comedians*? Something like: *When I stand up there on the stage* – I still hit my head on the ceiling. It might be literally true – but mainly of course he means it more like a metaphor – a way to say, that the world which Capitalism has on offer isn't big enough yet to accommodate his dreams or imaginings.

Anyhow back in Derby in either 77 or 78, Smith wont take it for long. He's at the very edge of the stage by this point, walking back and forth, pacing on the exact border, looking down off the low rise and into that other space – that other world, no-one in it and everyone eyeing it, a space in this case between him and the rest of us, a space not quite his and not quite claimed by the rest of us. Time passes. And then there's a moment like there always is, a moment so good I won't ever remember it, and could not in any case describe it, a moment in which he makes the jump and steps off the stage. He's off, he's over, gone into the emptiness down there, the band oblivious or inured to his probably amphetamine whimsy, and the music's all thump and screech and grind and he's wandering, caterwauling, out into the no-man's land/wasteground that he's somehow made his own now, barely tethered by the microphone lead and in some ways never to return.

That, was an inspiration. And no mistake of all.

* * *

Or start with a quote – it's the composer Robert Pisaro talking about Bob Dylan now, about Dylan's voice on the song *Like A Rolling Stone*, you can find the quote in Greil Marcus book of the same name – the book where Marcus, amongst other things, gives a blow by blow account of each and every one of the

numerous original studio-takes of the song. *This* is what Pisaro says:

> *Like a scientific instrument developing a will of its own, his voice quavers between trying to record the coming earthquake and **trying to make it happen**.*

* * *

I wanted to write to you about the edges of stages (the need to walk to them and look out, look over), the desire to step off them. About the magnetic attraction of the stage's edge. About the desire to step off the stage – at once an attempt to escape and exceed representation, and perhaps at the same time, a ducking under, a refusal of representation, signal of a desire to shake off its burden, or even of a wish to disappear.

I wanted to write to you about wanting performance that can somehow reach across that border, come out across the edge of the stage (in all ways we can imagine that might happen) or about the performance which draws those watching in the opposite direction, across and into a direct encounter or confrontation with that other world; performance that throws us directly into the logic, relations and time of the stage. About the resilient yet endlessly permeable border between that space designed for play and pretending and what's known as the real world. The border between there (where you are) and here (where I am standing).

It's not for nothing that a recurring image in much contemporary performance, has been the chorus-like line-up of performers at the front of the stage. The line-up is an act of mutual revelation and confirmation for both performers and audience – an initial ocular assertion, testing and probing of the border. We are all here, present and correct –

performers arranged at the edge, whilst the audience – you in this case – are all sat in your rows and facing those on stage. It's a blank face-off, a strict orgy of self-presentation and projection, a scene that can be endlessly layered and complex, especially in the hands of an artist like Jerome Bel who's *the show must go on* tracks such moments to the end.

I wanted to write to you about physical edges **and** about beginnings and endings – since we might think of these as the **temporal edges** of performance – and I wanted to write about that precisely because the negotiation of these physical and temporal edges is also the negotiation of the border between art and life – and because there – in that negotiation – there is always the question of where, in the end, a performance event has it's affect.

Years ago I wrote about the end of a performance of *Café Muller* by Pina Bausch at which the dancers coming back for the numerous curtain calls never once dropped the expressions of melancholy gravity that they'd maintained throughout the performance, an uncanny insistence, that ensured that even there, amongst the applause, the piece had somehow not ended; that its problem, its logic, its confrontation to us (and to the dancers) still remained and must be taken home, incomplete, still problematic. It was a curious end to the evening, infuriating and arrogant in some ways, as if those of us watching were somehow tricked, denied the conclusion and release we technically deserved, but at the same time the piece stayed with me, in part because of this refusal. I carried it with me all these long years, a time-bomb still ticking, still problematic.

Or come at this in a slightly different way. In Leeds, in some venue on the edge of town, in the mid 1980's the writer Russell Hoban and Impact Theatre Cooperative are staging a performance called *The Carrier Frequency*. It is a dark, funny, repetitive post-apocalyptic thrash of a thing to watch – a pool of water, lots of dying and reviving, an energy that's pitched somewhere between Tom and Jerry and Francis Bacon. It certainly made an impression, but for now I am just recalling what Russell Hoban wrote about the piece in *Performance Magazine*. He wrote – echoing the kinds of statements that came from Fluxus or Happenings artists in the late 60's or from Judson Church dancers and choreographers in the 70's – that the work was no more or less than a fact, an event; **It is not about something, it is something**.

The end of the piece – I saw it a few times – was always a kind of eerie calm. There was music and lot of smoke-machine mist in the air, there was dripping of water from the metal platforms that rose out of the pool on the stage. Drip. Drip. And the pool – which had been the site of relentless thrashing – was still and seemed very empty. I remember Claire telling me once that afterwards, on leaving the performance, spectators often liked to dip their hands in the water, as if to assure themselves that it was real, or as if thinking, in some small way, that they might cross that line and enter the world/space of the performance.

I wanted to write you about stages themselves. Hugo Glendinning and I have been photographing them, empty ones; since the year 2000 we've been making a series of pictures of performance spaces in professional and amateur theatres, working men's clubs, village halls, hotels bars and even outdoor locations. The stage of the Vooruit in Gent, grand, pristine, bordered in gold and with the motto Art Makes Us Better in Flemish, painted into the proscenium. The space of The Polish Club in Sheffield, half full of boxes, bedecked one November in premature tinsel. The formica tables and green

painted walls of a village hall in Derby – half badminton club come sports hall, half venue for pantomimes, its shallow stage a high-raise of maybe one metre and a half, its green-velvet curtains shut tight.

I'm tempted to think of these as performance photographs because for me they are always about imagining what might possibly take place in these photographed spaces in which performance is not present but in the air. Looking at these stages – some strewn with detritus, others totally clean, others occupied by the materials clearly intended for some future performance and yet others stacked with items that have no obvious connection to performance at all – it's all futures and pasts, all befores and afters, all what might have taken place or what might take place at some future point, or simply what can be imagined there – plausible or not.

Perhaps these pictures are also interesting because in them the charged or magical space of performance, the 'other world' of the stage, is shown lights on, without mystery, shown for what it is – a piece of architecture, a zone of possibility for sure but in the end not more and not less than a built container that is so many metres wide and so many metres deep, and so many metres high, a raised space, the route to which can easily be blocked using a table tennis table for example as in the picture we took at the Ecclesall Non-Political Club in Sheffield (now demolished), and anyway a space which can be used just as easily to store some cardboard boxes, to house a television or to stack and mend a hundred chairs, as it can be used to stage a performance of some kind.

Think about it this way: inside the theatre there are only the performers and the audience. Onstage the performers have some material items – flimsy or not-so-flimsy scenery, various props and costume stuff. The audience, for their part, have their coats and their handbags and the contents of their pockets. But that's all. *The whole of the rest of the world* – its physical locations and landscapes, its entire population, its complete set of objects and its unfolding events – is invariably outside, *emphatically absent*.

Theatre then must always (?) be: the summoning of presence in the context of absence. A bringing in of the world.

I wanted to write to you about stages and what is possible on them. About the desire to fit more on them (in may different ways) than is normally judged feasible or wise.

The need to reinvent theatre in order that it accommodate more. To smash some seats, perhaps, to make more room.

* * *

Or – at this mid-point in my writing – to start again in another way, and to think about community, about what kinds of work one might be interested to connect in a context like this.

As an artist you find yourself in a room, or a festival, with a group of other people. Some of them you know personally but you haven't seen their work, some you don't know at all but you once saw a show that they did somewhere and you either did or didn't like it that much or didn't really like it at all. Some you have met before, but don't really know them and you think that a friend once told you that their stuff is kind of like yours but different – it doesn't sound promising, but you think your friend was quite into it. This – meeting up with other artists – is the kind of situation that if you're lucky you can find yourself in quite often and over time you can

find some interesting variations too like you're not just in a room or a festival with these people you're on a panel with them in Warsaw or you're drunk in a hotel room with them in Aberystwyth or Bergen or Sao Paolo.

Before you know it people are addressing you, and these other people, in the plural saying "the kind of thing you do" or "the kind of theatre and performance you make" and you find yourself looking at your temporary mates and wondering what exactly is being talked about, and what purpose is served by corralling you – with your structuralist version of *Look Back In Anger* say – with that puppety-looking thing from Birmingham and that thing with all the backprojected video and movement from Belgrade. I mean before you know it you're part of a community you can't even imagine the edges of, let alone understand.

'This area of work' as people like to call it, having abandoned all the other names is a broad fucking church.

I'm going to leave that thought there for a minute.

* * *

What did Steven Connor say to me about Baudelaire in a discussion a while back? It was something like this: "That the child's elemental or foundational relation to a toy is to test its limits, to ask in effect 'How can I break this?'"

I've been thinking about how this simple question might also describe our relation to theatre. Not just ours in fact, perhaps such a question might serve to frame a lot of the work we might focus on here.

How can I break this? It's a good, disrespectful question – curiosity and vigorous will mixed with an enjoyably careless assumption that the thing might not matter that much (might not be precious) in its unbroken form, or powered by a healthy assumption that if the thing (called theatre) breaks it can be replaced or that in its broken form it might be as interesting or useful, or perhaps even more interesting and more useful, than it was in its original condition.

How can I break this? could also be the kind of question that a bunch of rough and ready scientists might ask, since trying to establish what something *is* could also involve an attempt to discover its limits, its edges, and the full extent of its capacities in any number of directions.

Footnote: Matthew Goulish from the Chicago performance group Goat Island and I started a kind of virtual think tank some years ago under the title Institute of Failure. Matthew reminds me when we are talking about the project that if you want to understand how a system works – in philosophy or the construction industry or in the funding of arts – you should first look, at how that system fails.

How can I break this?

Meaning:

What kind of stresses and strains, reversals, upendings, speedings up, slowings down, shatterings, dissections, refractions, distortions, simplifications, complexifications, parings down, new disciplines, hybridisations, crosscuttings, remixings, and re-wirings can I subject this form to? And what might be produced in the process?

If I break it, will it maybe still function? Might it function in some new way? Might it do something new? Or might it do something old and worth returning to? Or produce some unexpected combination of affects old, and new?

How I can I break this? What kind of fun can I have with the rules of this game, this form? Or how can I

modify, expose, weaken or otherwise intervene so that it can do something that I might really need it to do?

How can I break this?

It's certainly a question to the theatre that can be answered in as many ways as there are artists willing to give it a go. Perhaps what there is in common through all of the work that we'd hope to see gathered in a context like this one *is a desire* to remake theatre and performance in some way – a picking up of the form, a delinquent turning it over. To break it. To open the space, as if it might be better broken, or better wired a different way. To make new tools out of old ones.

Whatever else we might disagree on as artists – and there are and will be very many things – that could be a first point of agreement, or a ground of connection.

* * *

Dear Lois, Dear Robert,

Thanks for inviting me to speak. I'm slightly conflicted at this point. Because I fear that I honestly don't like that much performance that I see and I rarely go to the theatre proper as such, and when I do go I'm puzzled more often than not. And I think that for all the connections I can make there's something profoundly singular and 'alone' about what we do in our place in Sheffield, as there is something quite alone and quite singular about a great many of the artists that I really respect. I guess that I can see connection but I can also see something else – a kind of resolute and obstinate private plugging away at something, a kind of mono-focus, rather anti-social, for all that these artists work might meet or cross with other things.

I don't know what to do with this thought right now. It's in danger of breaking the flow I think. But I am writing it to you here anyway, in the form of an aside, which I hope no one will notice.

* * *

A second possible line of connection between the artists that interest me would follow from the first, namely that all this messing with theatre, this prodding at its edges and rules – is driven by a deeper desire, albeit one not so much mentioned and maybe harder to talk about. I'm talking about the desire to speak better, more precisely, with more vigour, with more passion, with more honesty, with more directness about, to and into the situation in which we find ourselves – now, at this particular moment in history and in culture. The times shift – the reality of our lives, the cultural and political contexts – all of these are shifting all the time and the artists that I'd expect to find here, are, I think, driven to some extent by an imperative to address these times and to find new approaches to the medium of performance that will better enable that.

For me the artists working in performance that I really follow are connected in the sense that for them **form matters** – their work is made in the full knowledge that **what's** said and **how** it's said cannot readily be separated, that the forms they choose, are central to their articulation as artists and to the experience they give audiences. For these artists – for most of you here I think – **how** things are said is always a question – not a given – not something anyone just walks into – but rather a deep question that always demands a set of inventive answers.

* * *

Lois, Robert,

Another thing about that isolation I wrote about. I mean. I don't even think it's a bad thing. I'm not sure that it's good to be too much a part of anything. We have our own stuff to deal with, right? We make connections but they are loose – nods across the street, streets that diverge, paths that cross in a bar somewhere, on a panel in Italy. It doesn't need to be more, or more firm than that, does it?

* * *

The artists that I'm interested in are also joined – according to me – in a certain level of attention, question, invitation and demand to or at the spectator, a kind of focus on the 'audience' as theatre likes to call it. It's a double thing this – I'm going fast now because of the time pressure so please forgive the shorthand – a double thing, a kind of always shifting balance between two apparently contradictory positions. On the one hand, re the audience, there is I think a real trust in the spectators ability to cope, in his or her capacity to make a way through a performance experience that perhaps lacks some of the signposts that our friends over in realism swear blind that people need. There's a trust, a belief, that an audience like to be challenged, to be thrown in at the deep end and made to deal with stuff. Not everyone of course, there are sometimes some walkouts. OK. But on the whole, what I find is that audiences are really prepared to go a long way and that they really like the challenge, especially if you make sure there are some decent gags along the way. On the other hand though along with this trust of the audience is the opposite – a really healthy mistrust of what audience is as a formation, of what it 'wants' as a collective presence, of who it's made up out of in the first place – these things are all, like

form, serious questions for us rather than easy givens.

* * *

Lois/Robert. A final aside, I promise.

This thing about the singularity, the lack of connection. It goes deeper I think.

I want to say this to you, privately here, because it might be misunderstood if I say it in public. The artists that I give a shit about are, in a certain way, working for themselves, following their noses into territory that they don't yet know and don't understand. They do this out of a guess – an assumption, a gamble maybe but I think a reasonable one – that what grips, disturbs, amuses or fascinates them will spark a kind of vivid alchemy or an intellectual chemistry when it meets a public, a meeting that they are extremely eager to bring about.

What they aren't, really, is a comfortable part of an economy that sees the arts as social provision, extension of leisure services, socio-political band-aid to major political wounds or as cogs in the burgeoning cultural industries. We can all talk the talk I imagine. And of course there are ways in which we can and do meet those agendas. But I think we aren't there in the first place to be part of someone's provision of anything. According to me the work comes from artists, singular and disconnected as much as connected, and from strange, often private inclinations and from positions in respect of society that are often deeply, quietly and productively subversive.

* * *

I am in Gent, Belgium making a performance here with 17 children between the ages of 8 and 13. No

time to talk about it now. Instead now I am sat on a probably-Ikea sofa and thinking ahead to Thursday in London at which point these words, sketched into the laptop will have become or will become (a) speech.

When I said before that I would write about the temporal edges of performance, beginnings and endings, in fact I only wrote about endings. So now, here at the end I will write about beginnings, in the sense that I am writing proposals for a possible future – a list of the theatres that I am interested and excited to see.

A theatre that places you in a world rather than describing one to you. Or which places you in a situation rather than describing one to you. A theatre in which your agency as a watcher is an acknowledged and known part of the performance from the out-set. A theatre that feels more like event. A theatre that makes demands. A theatre that is ugly, awkward. A theatre that likes its ambiguities, its undecidednesses, its disconnections. A theatre that can be very very funny, ridiculous, absurd. A theatre where the comedy does not ever, quite, confirm itself as comedy. (This last a paraphrase of what the performance artist Gary Stevens once said to me years ago and I am still quoting it, always). A theatre that is all bitterness and mourning. A theatre that threatens to make the very possibility of an audience impossible – a theatre that spoils any notion of a social contract before it has even begun. Or something much more fun, down to earth and matey – that also works for me. Did you see any of Jonathan Burrows' – *Duets*? Brilliant. It is dance really but that's OK.

A theatre that thrives on the unstable and on the trembling, on the thrill of live decisions on the collision of different materials and different narratives.

A theatre that does not hide the fact that here, in front of you, are a bunch of people doing something, reading possibly. No fourth-wall kitchen sink bullshit. A theatre that critiques its own language even as it is using it. A theatre that divides audiences. A theatre that can also bring audiences 'together' even as it critiques that word and the very idea of what together might mean. A theatre constantly looking to breach its own edges, to duck into performance, into installation, into event, into blankness. A theatre that unpicks its own rules, strips bare its own authority. A theatre that dreams of being somehow more or somehow less than itself, a theatre, or performance that has the ambition to be life, to touch life, to change life. A performance that will not be put away – I am remembering again the gazes of Jerome Bel's dancers in *the show must go on* and again the end of *Café Muller* and again so many performances over years that have left shards, and lines and time-bombs inside of me.

A theatre that can trust its audience. That does not insult them by telling them things that they might reasonably be expected to find or come to or speculate about all on their own. A theatre that mistrusts its audience. Teases them. Probes. Questions.

A vulnerability. A frailty. A provisionality. Homemade. Human-scale. A slipperiness. An air of anti-art. A workman-like attitude. A rawness. A bleakness. A melancholy. A hilarity. An anger. A lack of compromise. A theatre that insists on its own time, brings you into collision with its own temporality. A theatre that has no beginning and no end.

* * *

It's over, more or less, but then, in a kind of aftermath some other things unfold. It's that kind of

state in which you walk down the stairs of the theatre, not yet speaking to your companions and when you get to the bottom you dip your hand in the water onstage to check that it is real, or to see that it *is* water, or to feel a little bit the reality of what was there, of what those other human bodies were thrashing in. The kind of state, as you walk down and out, in which everything you saw or thought about is circulating and you think that you should maybe write something down but you cannot write and you intuit somehow that there's no point in writing anyway, that the core of what's here will be gone before you form a single letter with the pen.

What Pisaro says again:

*Like a scientific instrument developing a will of its own, his voice quavers between trying to record the coming earthquake and **trying to make it happen**.*

I am sat here and writing. Gent. 23.35. 10 April.
I am days away from you.
I am sifting fragments again – working my way thru this disorganised suspension of stories, phrases and thoughts about performance.
I am typing. I write these words:
You. Are. Not. Here. To. Record. The. Coming. Quake. You. Are. Here. To. Make. It. Happen.
And then I pause and then I type again:
If. There. Is. No. Room. Then. Rip. Out. The. Seats. To. Make. The. Space. Bigger.
Or.
Step. Off. The. Stage.

for mark e. smith.

Step off the Stage was the opening polemic of the SPILL Symposium, presented at Soho Theatre on Thursday 12 April 2007.
Tim Etchells is Artistic Director of Forced Entertainment .
www.forcedentertainment.com
www.timetchells.com
www.spillfestival.com

You, the Spectator

Nick Ridout

Theatre, of course, is rubbish. It happens in the evenings, when there are more exciting things to do, and it does go on a bit. It typically involves people dressing up and pretending to be other people, putting on accents and shouting too much. Since visual art practice has so decisively repudiated, problematised, complicated the whole business of pretending, it's hardly surprising that the theatre, still apparently a way of representing away in complete naïvety, should be given a wide berth, involving, not infrequently, disdainful glances.

Artists developing what came gradually to be known as performance, performance art or live art even founded their practice on a rejection of everything theatre had come to represent. Marina Abramovi?, for instance, recalled her opposition: "Theatre was an absolute enemy. It was something bad, it was something we should not deal with. It was artificial… We refused the theatrical structure." In the UK our cultural institutions, including public galleries and the commercial art market, have clearly embraced this position. Art (which can encompass performance, live art and dance) is cool; theatre is

not. Theatre makes a show of itself in high-rent but tawdry locations, such as Shaftesbury Avenue, while art shows off its cultural capital by driving up rents wherever it goes. This distinction, as articulated by Ambramovic and sustained in much critical discourse since, rests on a misunderstanding of what theatre might be, even if it may reflect its condition in a certain mainstream situation. Theatre is still widely assumed to be about creating fictional representations of the world and presenting them to a largely passive public, either as entertainment, or as bourgeois self-improvement.

Enter Peter Handke. In 1966, at the Theater am Turm in Frankfurt, the "usual theatrical atmosphere" is maintained: curtains, ushers, programmes, house lights. A campaign of negation begins: "It may be the case that you expected what you are hearing now. But even in that case you expected something different." The theatre announces the renunciation of all its familiar devices: "There is no drama. No action that has occurred elsewhere is re-enacted here. Only a now and a now and a now exist here. This is no make-believe which re-enacts an action

that really happened once upon a time." Instead the public itself becomes the subject of the encounter: "You look charming. You look enchanting. You look dazzling. You look breathtaking. You look unique. But you don't make an evening. You are not a brilliant idea. You are tiresome. You are not a rewarding subject. You are a theatrical blunder. You are not true to life."

The event, it seems, has failed. In abandoning the attempt to re-enact anything that might once have happened, or might have been imagined to have happened, the theatre has failed to produce anything real, either. Not even the audience is "true to life". Everything is contaminated by an air of fakeness. We have somehow blundered into a public space where we may look enchanting, but where we are, in reality, wherever that is, merely tiresome. In this double bind not even life itself can be true to life. How then, might we successfully pass as human beings, either in the theatre or in our natural habitat? Our natural habitat itself is already beginning to look rather worryingly like a theatre, or maybe a zoo.

In *Publikumsbeschimpfung* (translated into English as *Offending the Audience*) Handke used the structure of the theatrical situation itself to engage in a playful demonstration of the way in which that situation is designed, not to facilitate fictional representations, but rather to stage mediated and compromised encounters between human beings. The prime purposed of theatre is thus not to produce illustrations for an audience, but rather to produce audiences out of a special kind of encourage, an encounter in which error and misrecognition seem more likely than truth. In any event, it is clear that, from Handke's perspective, theatre is not where we go to see stories acted out, although that might happen, it is where we go to watch ourselves

watching and being watched. The theatre is always already relational, long before Nicolas Bourriaud proclaimed the arrival of relational aesthetics. Just as much recent art has revealed the subject of the museum to be the public, Handke's work, and much that has followed it, is about what it means to participate, as singular individuals, in the formation of a public through the medium of the real, live encounter. All real, live encounters are, of course, mediated. Welcome to Spectatorland.

Spectatorland, by the way, is a location devised by Joe Kelleher, whose writings about the experiences of these strange public encounters sometimes take the form of "postcards from Spectatorland", often dispatched from places in Europe where they do things differently. The Norwegian collective Baktruppen, for example, presented its 2002 show *Homo Egg Egg* in a theatre in which only projected images of the company were visible on stage via a live video feed from the space underneath the audience bleachers where the performers were going about their work. As Kelleher writes of this production and the work of Latvia's New Riga Theatre:

> *"'What happens' happens as a sort of testing of the real that has to do with a feeling out of the proximate, the other stuff that is also here, a recognition if you like of neighbours, whose other worlds – be they over our heads or under our feet or right beside us in the same room – overlap and (potentially) interact with our own."*

In anther corner of Spectatorland the screws are being tightened. In *This Progress*, presented at the ICA in 2006, Tino Sehgal produced a work which, while owing no obvious debt to Handke or any other theatrical practice, might fruitfully be thought

of as theatrical. Entering the downstairs gallery at the ICA my friend and I were met by a boy of about nine who first introduced himself and then began a conversation by asking us what we thought progress was. The situation seemed to require an authentic response. To fake it would be condescending. There are strong ethical arguments against palming off comfortable clichés on young people. At the same time, I could draw upon the typical intellectual furniture of the left-leaning intellectual, offering recycled versions of creative destruction, summoning the ghost of the Communist Manifesto to intone, smugly, that "all that is solid melts into air". But how hollow would that sound? Not only would my nine-year-old interlocutor detect the humbug like bullshit on a stick, my friend would see right though it too. At that moment, for sure, she was watching me struggle with this nasty social predicament. And I was watching her, doing the same thing. Waiting, in fact, for her to speak first. As if that would let me off the hook. Eventually, we dredged up between us some basis for a conversation about the positive and negative values associated with progress, until, after a few minutes and a walk across the gallery space, we were introduced to a girl, somewhat older than the boy. The boy handed us over to our new conversation partner with a succinct summary of our views on progress, which was both so accurate and so damning in its glibness that I felt terribly ashamed of myself.

What this encounter, and the affective response it produced, depended upon was distance and representation. There is distance everywhere, even if it is almost always distance that we feel as proximity. We are all three (or four) of us trying to get along, to make the social thing function, but we all know, too, that this is no social thing, at least not in the ordinary, everyday way. We are in an art gallery, for a start: it is as though our conversation was already pinned up on the wall for inspection. The distance between us may look tiny when compared with that created in a theatre between an actor on stage and a spectator in the back row of the auditorium, but it is just as effective and involves the same process: representation. Even if we were to go "backstage" (and that is precisely where *This Progress* is about to take us, through the corridors and stairways of the ICA), we would never get "behind" our interlocutors, we would never be "in on it" in the way that they are, never get outside the representation. In spite of the effort to cook up an actual live conversation (precisely what so much theatre is always labouring so earnestly to achieve), the set-up depends upon the encounter between the participating objects being, in effect, scripted. It is not the scriptedness as such that makes it theatrical, however. It is the distance it places between me and myself, the gap between the various versions of my own authenticity that it opens up. I watch myself struggling to respond and wince at my own failure to present a self I am comfortable living with. The distance mediated the encounter at every level. Nothing is ever immediate. We appear only by means of representation, and at a distance. We appear always, that is, as spectators. It is this distance across which representation occurs that makes this experience of Sehgal's work a theatrical one, and which encourages me to consider it in the light of other work currently being made out of theatre.

The Italian collective Kinkaleri concluded a three-part exploration of theatrical representation with its 2004 production *I Cenci/Settacolo*. The piece takes the first part of its title from Antonin Artaud's play *The Cenci*. The second part is the Italian word

widely used to refer to a theatrical production: spettacolo. It suggests that, all appearances to the contrary, this production is proper theatre. From the very beginning of the show, the conditions by which we are accustomed to accept that something is un spettacolo, proper theatre, are painstakingly observed – that is to say they are both met and placed under a spectacular kind of scrutiny.

The stage is bare, with a grey floor, black curtains around three sides. A microphone on a stand is placed towards downstage left. The lights come up. Three basic conditions of theatricality: a space arranges for the benefit of the public, an amplification device to make sure that we can hear and an illumination device to ensure we can see. House, sound, lights. From the start the lights begin to function autonomously, passing through a sequence in which a series of perhaps six lanterns, each of which provides basic stage cover, albeit with a certain amount of shadow depending upon the direction of its throw, comes up and then fades, one after the other, so that we witness a series of lighting states, each of equal duration, following in orderly but meaningless progression. This basic sequence will be the lighting for the entire production. While its timings seem to vary, the show continues to move through each state with apparently no motivated connection between the states themselves and whatever action they might be illuminating: any moods, atmospheres or meanings generated by the relation of lighting to stage action are apparently entirely coincidental. What is striking is that the impact of this is not without affect. Moods do change; atmospheres are generated. The relationship between light and time is itself enough to do this. To add moving bodies to the space is immediately to open up such an enormous range of possible combinations of bodies in space and time that the affective possibilities start to appear incalculably vast. Suddenly the idea that you might bother to try laying over the top of this a secondary layer of representation – such as, for instance, dramatic narrative – seems almost entirely redundant. After all, we have only just started to explore what might be achieved without anyone even appearing on stage.

The microphone just stands there, awaiting the appearance of someone who might speak to us. No such person appears, at least not at first. Instead, as the lighting sequence begins a music track is played: Rod Stewart's *Do You Think I'm Sexy?* For about two or three minutes this is the show: lights, an unused microphone and the song. Eventually someone emerges from behind the curtains and advances downstage holding up a duvet so that they cannot, as it were, be seen. This person lies down under the duvet for a while, and then gets up, still hiding, and exits, leaving on the floor a sign printed with the message "Houdini 1901". Is this perhaps the only way out for a theatre that follows to the letter Artaud's requirement that it should escape representation?

As Tate Modern's *The World as a Stage* (24 October 2007 – 6 January 2008) invites us to consider again the relations between visual art and theatre, is it too much to hope that our cultural prejudices may shift a little, and that theatre might seem, for a moment, a little less "rubbish" and as capable as the next art form of examining its own productions with rigour and humour?

You, the Spectator was originally titled *Art & Theatre*, and published in Tate Etc., Issue 11 / Autumn 2007. www.tate.org.uk

Profile: FrenchMottershead

Mark Wilsher

You are chatting away to someone and they start to look over your shoulder in search of someone more interesting. You are at a party and someone forcefully and publicly corrects your point of view. A stranger brushes up against you at the bar. These might be three ordinary moments. But they are also three carefully worked out and premeditated 'micro-performances' organised by the duo FrenchMottershead (Rebecca French and Andrew Mottershead), artists who make performance art without performing, who appropriate the syntax of self-development workshops and audience involvement to quietly disruptive effect. The *People Series* (2003 – ongoing) consists of a simple set of instructions customised for the context of each manifestation. You are invited to pick an action to be performed at any time during the time span of the event, anything from calling someone by the wrong name to spilling your drink. The performance unfolds almost totally invisibly. But reality is made slightly different; certain situations are constructed as the micro-performances play out.

Working together on a series of projects since 1999 they have explored ways of framing the micro in order to deconstruct the languages and dialects of performing the self. This kind of almost subliminal behaviour is their stock in trade. Where they differ from other artists investigating similar terrain is that the most important part of the work tends to happen internally in the conscious awareness of the audience, and it is often very hard to see their performances taking place unless you are cued in and know exactly what to look out for. Indeed it is perhaps better to talk of 'participants' rather than 'audiences' because it is the sort of work that really demands active viewer investment and involvement to understand.

Their current project *Club Class* (2006) has taken place at Tate Modern and Tate Liverpool as part of the Liverpool Biennial, and will also tour to London's ICA in February 2007. It involves recruiting anything up to 40 self-selecting volunteers as performers who each start the day with one of a choice of workshops (clothing, body language, bad behaviour and surveillance for instance) designed to

get them thinking about their own relationships with 'the social'. Expert stylists or dancers work on the performative aspects of dressing and using the body to lead each participant to a personal understanding of their previously unformulated positions. These personal stances are then challenged. Or rather, by nominating each participant as performer, everyone is effectively given license to challenge him or herself by trying out some previously unthinkable behaviour. Walking out into the public arena wearing someone else's clothes, for instance, or adopting a notably different array of body language is especially empowering because it's an experience rooted in our everyday interaction with the *polis*, and we are all equally expert at the essential syntax of these kind of daily negotiations. At the first performance of *Club Class* at Tate Modern in October, people casually posed in clothes that were, frankly, too young for them, and rode down the escalator handrails like naughty children. I came across one woman making slow head movements to the tick-tock soundtrack of an installation in a gallery, and watched a perplexed audience gather to watch for a few minutes before her friend came to lead her away. Although programmed by the gallery this particular event, like everything that happened that afternoon, was almost entirely unannounced and unsignposted. The public might have read it as performance art, prank, or psychiatric patient. Like the majority of these slight moments it went inevitably unrecorded. Although the artists might go all out to document their projects a large part of the work ultimately ends up existing only like this – as a verbal account reported second hand.

The posed photographic works titled *Shops* (2005/6) exist as documents of the customers of particular shops at particular points in time and as such uncover, unite and display some very different social groupings that previously would not have manifested such definition. For a few days staff are instructed to invite anyone making a purchase to return for the group portrait at a specified date and time. Standing on the street outside a pet shop, record shop, or butchers, they are revealed as a real but fragmented community. The personal experience of taking part in such an event though, is more that of solidarity and common purpose. These people are now able to literally see themselves as a community just as we see them. A print of each piece is permanently on display at all of the participating outlets and they reveal morphological similarities that almost verge on the comical; a pet shop has a constituency of slightly doggy looking types, while the alternative music store attracts a rather sweet bunch of teenagers dressed in the commonly accepted signifiers of rebellion. Customers of the piercing parlour show off the tokens of their individuality together, and underneath each image everyone has been invited to write the item that they visited their respective shop in order to buy (dog chews, Napalm Death, clit hood and so on).

The best of FrenchMottershead's work empowers and confuses its different audiences in equal measure. The social is dissected and discovered to be just a set of arbitrary practices, techniques of the body adopted because they were 'convenient' quickly become 'conventional' with repetitive use. As an observer who knows that something is going on but isn't sure exactly who is meant to be taking part, every little detail of every interaction during one of their projects assumes an unfamiliar significance as a potential performance. Does that person *know* that their underwear is showing? Was my polite witticism *really* funny enough to solicit such gales of laughter? For once it

is art that actually achieves the popular ideal of raising your awareness of daily life.

For the participants, arguably the only real 'audience' for the work, it is empowering to be given permission to be someone else for a while. Situations are constructed that allow a stronger experience of being present, and in a sense the work endures for as long as those people carry that feeling with them.

Profile: FrenchMottershead was originally published in Art Monthly, Issue 302, December – January 2006 – 07. www.artmonthly.co.uk

Name in Lights

Mary Paterson considers the meanings of fame in a new national competition and art installation by artist Joshua Sofaer, produced by Fierce! Festival in Birmingham.

Elvis Presley. Nelson Mandela. Posh and Becks. When is a name more than a person? And when does a person deserve A Name? This spring, in a national competition devised by the artist Joshua Sofaer, a new name will be written onto the public consciousness. Entry is open to all, and the prize is to see your name – or your mum's name, or the name of your favourite celebrity – emblazoned in lights, twelve foot high, in Birmingham city centre. Each nomination for a name must be accompanied by up to 150 words which describe why that person should be chosen. There are all the normal ways to enter – email, text and post voting – and nominations will be judged by a panel of famous media experts. So far, so familiar. The prize offers instant celebrity, or at least notoriety, but the project's web address – www.notcelebrity.co.uk – hints that all is not as simple as it seems.

Seeing your name in lights is an old fashioned way to be famous. It harks back to the days when Music Halls and Picture Houses advertised their stars' names above the door. Maybe that was a better way to be famous than today's high-speed celebrity turnaround – having your name in lights is more permanent than page 15 of Heat magazine. But whereas celebrity magazines nowadays feast on the ordinariness of their subjects – Britney with no makeup! – Paris eating a burrito! – the big celebrities of the past were defined by enigma and control. There is a poignant roll call of those whose name in lights disguised a private tragedy: Judy Garland, Marilyn Monroe, Billie Holiday.

The truth is, fame as an industry hides just as much now as it ever did. The managed, studio fame of the forties and fifties has simply been replaced by a managed, paparazzi fame of the nineties and noughties. There was nothing permanent about most music hall stars, just like there is nothing normal about the people featured in celebrity magazines. And yet there is something anachronistic about Sofaer's combination of a contemporary format (the ubiquitous celebrity competition, itself in the midst of its own 15 minutes) with an old-fashioned prize (the industrial physicality of the name itself). However similar the mechanisms that create them, these are in fact the trappings of different definitions

of fame. And by drawing the two elements together, *Name in Lights* not only explores these different meanings, but also examines the ways they are made.

Celebrity competitions are impossible to ignore. A new one starts just as another ends, following the same tried and tested format. Eager competitors (either people who want to be famous or people who want to be more famous) vie for an intangible prize (usually, but not explicitly, more fame); they are judged by a famous panel of 'experts', and voted for by you, the member of the audience. It's a complex setup that *Name in Lights* seems to follow – centred on audience participation, but backed up by press coverage, supplementary programmes and the self-perpetuating fame of the judges and hosts.

In *SFMOMA Scavengers* in 2006, Joshua Sofaer organised a huge scavenger hunt throughout San Francisco. Members of the public were given tasks in the form of clues, and instructed to collect various materials in the hope of winning a cash prize. The winners took the cash but all the participants' entries were shown the next day in a temporary exhibition: Joshua Sofaer's exhibition. His visitors paid him so they could bring him the tools of his show – in return, they got a unique 'art experience' and a day of games around the city. Just who is in control here? – the artist, with his prescriptions for our enjoyment, or the public, on whose complicity the whole project depends?

Likewise, *Name in Lights*, and the make-me famous TV extravaganzas that it imitates, depends not just on our complicity in an artist's project but also, and more importantly, on our acceptance of the duplicitous mechanism of fame. There is a hidden winner in Sofaer's project. Basking behind the assumed democracy of mass participation, and the unexplained edifice of the 'life-changing' prize, is the

artist himself. Ostensibly, the prize will make someone (else) famous, but the only certainty is that it will raise Sofaer's profile. Perhaps he has become an art world Simon Cowell – the industry insider who pretends to fulfil someone else's dream while he lines his own pockets.

Certainly, *Name in Lights* seems to reproduce the process at its core more faithfully, and less self-consciously, than *SFMOMA Scavengers*. The earlier project was a parody of the art world, which both feigns meritocracy and thrives on the spin of 'art stars'. But it was deliberately playful and deliberately dramatic: its participants were likely to remain in the know. *Name in Lights*, on the other hand, is less enclosed. Both the competition and the final piece will exist outside of an art gallery, and publicity will be distributed widely – beyond an art audience. Its constituent parts – the nominations, the intangible prize, the famous panel – are almost carbon copies of the devices used in TV talent shows: so where's the ironic distance of parody? More to the point, *Name in Lights* exists in real time, in the 'real world', while *Scavengers* condensed a process into a ticketed, weekend event. Imitation is the sincerest form of flattery, and what could be more postmodern than a high-art copy of a derided, low-art form?

But if Sofaer is imitating *The X Factor*, then he's made a few deliberate mistakes. Firstly, there is no TV show. In fact, there is nothing to hold on to apart from co-operation itself: no audience payoff, in other words, except for taking part. With no promise of entertainment or group activity, the competition lionises the concept of fame, and encourages participants to define their own boundaries. This is where Sofaer makes his second deliberate mistake: the 'public' that *Name in Lights* courts is intensely individualised. We vote in our millions for *Celebrity*

Big Brother, and are reassured that our vote counts. The weight and autonomy of our involvement is so well communicated, in fact, that more people vote for these shows than in the general election. But there is only a limited, stereotyped range of goods to choose from – the pretty one, the gay one, the one with the annoying laugh – so that the sheer numbers of voters coalesce into that anonymous, amorphous entity: the public. *Name in Lights*, on the other hand, gives us the whole world to choose from (in theory) – and then it trusts us each to make up our own reasons. We don't vote as a public, we nominate as individuals. The competition has been stripped down to its bare bones, both amplifying its importance and enfranchising us, as individual members of the public, with real freedom of choice.

Reassuringly, Sofaer is no Simon Cowell. He gives us the egalitarianism that the fame industry pretends, but never quite delivers. And yet this exaggeration of the familiar competition format also exposes its sleight of hand. There is a false alchemy required to reconcile mass adulation on the one hand, with the belief that everyone can become famous on the other. Famous people are special, runs the paradox of modern celebrity, and everyone deserves to be famous. Here, the judges' authority stems from their own fame, and it is never made clear what criteria they will use to decide the winner. Instead, as audience and participants we must either all agree, implicitly, what it means to be famous – perhaps there is a calculation based on hair length and wealth-to-age ratio – or we must trust, implicitly, some famous people to make the right decision. In fact, just as limited choice allows the producers of ITV to control who the next pop starlet will be, unlimited choice gives Sofaer's judges the chance to decide the conditions of fame. The individuals who sent in their nominations have

become re-aggregated, through the judging process, into an amorphous public.

Distilled in this way, the celebrity competition appears duplicitous and manipulative, but it is still no closer to defining fame. At some point, that decision is always made by something outside the perceived democracy of the competition – by a judge or a producer. And once fame has been bestowed, it gets naturalised. Paradoxically, fame's ever-decreasing currency survives by not being questioned, while the allure of fame depends on it being seen as an unquestionable right: celebrity as a way of being. And this is the magical allure that the second part of the project refers to. While the competition element exists conceptually – through the call out to participants, associated talks run by the BBC and Ikon Gallery, and each self-determined nomination – the prize will be an awesome spectacle, an astonishing piece of public sculpture. Huge, glittering, magnificent, the object itself will be an unmissable symbol – a symbol of Somebody Important.

It is unusual nowadays to be famous for a name alone: they usually come accompanied by a photograph. In fact, to be known as a name and not as a body confers a special, sombre status, usually reserved for politicians or for people who have been famous for so long, and on such a scale, that they become synonymous with the concept. However many Michael Jacksons there are in the world, for example, they will never reduce the excitement associated with the singer's name. His name has become a totem for celebrity: Michael Jackson means fame.

This relationship of meaning does not just work one way; our names also have an inexorable effect on our behaviour. If they don't define us fatalistically, they do affect the choices we make and

the ways we are perceived (just imagine sharing a name with Margaret Thatcher or Tony Blair). In 2004, as part of *Namesake*, Joshua Sofaer travelled to meet the only other Joshua Sofaer in the world; the other one's a New Yorker, and a member of Jews for Jesus, an evangelist group dedicated to 'saving' Jews by introducing them to Jesus. 'Joshua Sofaer' means 'Saviour' and 'Scribe' in Hebrew, so which one has best lived up to his label – the missionary or the artist? And would either of them be doing what he does with a less unusual name, or a less Jewish one? It is tempting to hope that the person whose name goes up in lights will have travelled on an irrevocable journey of his or her own towards stardom. A name destined to be famous, a name with 'star-quality'.

But the setup of Sofaer's project has already proved that fame has no stable meaning, and the chosen name won't be anything more than a symbol of whatever fame means to whoever is looking. In this part of the project, as in the competition, Sofaer has stripped down and amplified the symbol of 'fame', exposing both its power and its failures. The name in lights will be huge – twelve feet high – much bigger than the names above theatres that advertise their stars. And, just as the competition has no TV show, the name has no context. The winner will not be starring in a West End production; she or he will not be coming to a screen near you soon. There is no advert, no performance – nothing but fame itself.

That is not to say that the type of name won't necessarily have an effect on which one is chosen. But the decision rests, again, with the whim of the judges and their circular relationship with celebrity. Perhaps they will be swayed by political correctness – choosing a Middle Eastern name, an Eastern European one – or perhaps they will just choose a name they all find easy to pronounce. Perhaps they will choose a name that belongs to someone who is already famous.

Of course, it is not the judges, or Joshua Sofaer, or even the entrants, who will ultimately decide what fame means, but the audience itself. When it is up, the name in lights will say little about the person it belongs to. It will be both an overwhelming piece of public sculpture and a mysterious indication of something unknown; a fetish object; a floating signifier that means 'fame' but gives no indication of what fame means. Perhaps the final act of *Name in Lights* will be a metaphor for the fame industry itself – a lumbering industrial process that is constructed entirely of the audience it must manipulate. Because it is the audience, buying into the implicit belief in the fact – if not the definition – of fame, that is the real star of this performance. By combining and refining anachronistic elements of the construction of fame, Sofaer shows us the term has never been static. Moreover, it cannot be defined by the process that makes it, nor the systems that prop it up. *Name in Lights* removes the mundane surety of the endless mechanism of celebrity, and does something magical: it puts the mystery back into fame.

Name In Lights was originally written in May 2007 to support Joshua Sofaer's project *Name in Lights* which was commissioned by Fierce! Festival and the Hippodrome. The winning name was Una White and was exhibited above Birmingham Central Library, Chamberlain Square, 17 May – 3 June 2007.
www.notcelebrity.co.uk
www.opendialogues.com
www.writingfromliveart.co.uk

Review: Richard Dedomenici *Superjumbo*

Tim Atack

Ladies and Gentlemen, tonight, Richard Dedomenici is going to be full of strange information. Some of it will be useful. And some of it will not be useful. And some of it will just be strange.

Sat in a gaffer-tape-and-string mock-up of an airline seat and adjacent windows, Dedomenici rambles through a collection of anecdotes and observations, turning to speak to a camera that relays his big cheeky face onto a hanging screen which faces the audience. As a result the whole piece is literally delivered as an aside – albeit one transformed into an open and intimate monologue to the room. And what an odd room to deliver it in … wood panelled, parquet floored, musty … as if Dedomenici were briefing, say, the Joint Intelligence Committee somewhere in Whitehall. Now there's something I'd like to see.

Why would I like to see it? Because it would be hilarious. Dedomenici is a mess. He's a fucking disgrace. Under-rehearsed and forgetful, he's reading his half formed script from the inside of an airline safety instruction card. Some of the notes don't even make sense to him ("What? Eh?") He's

using a recalcitrant remote control to operate / not operate the surrounding technology ("come on, come on, work. Play the clip. Play the clip. Just this once.") Anecdotes trundle to a halt, having gone nowhere. It's all in-jokes, gas and filler. He's crap, and it's great.

Yeah. You heard me. Great.

"I know some of you paid 12 quid for this, which is appalling, quite frankly," mutters Dedomenici at one point. "Like I say this is a work in progress. It's going to be better when I do it properly," he claims, before pointing out that the eventual staging of the show 'proper' and its specific circumstances (in a small flat, to a largely invited audience of British Council reps during the Edinburgh festival) will probably preclude us ever seeing it. What we're getting is notes for a possible show; a flight plan, a forethought.

What's the show about? Oh shut up, who cares? Apparently it's ostensibly something to do with aeroplanes. Dedomenici's usual preoccupations with the absurdities of modern politics appear to have taken a seat in economy class just for this trip,

and instead the journey is largely a personal one, illustrated by stories about school crushes and arguments on holiday. Occasionally the Dedomenici of old, the artist who produced *Political Top Trumps* or attempted to impose a congestion charge upon pedestrians during the Edinburgh Fringe, makes a brief appearance: he throws us some interesting titbits about depleted uranium being used to weight the wings of 747s, cracks wise about the airline industry being susceptible to three types of strike – lightning, bird and industrial. But the stream of consciousness is what engages, not the thematic unity of the material.

The port window behind Dedomenici relays jittery home videos of past airline flights (oddly affecting in their amateurishness) switching now and then to other archive footage, morphing at one point into the prompt from a karaoke machine so that young Richard can sing along – with no apparent purpose, as per usual. He performs in the mode of stand up comedians such as Stuart Lee or The Iceman (the latter often known to protest "it's not comedy! It's art!") but without the club comic's basic aim of prompting a constant hilarity. This is something of a relief, in that you are allowed frequent moments of quiet reflection; at one point Dedomenici tells a lovely story about being berated by his ex for leaving a mobile phone on during a flight and feeling, just for a moment, "as if we were back together again."

It's this sort of blurring of parameters that live art allows for so well, and the reason why Dedomenici is here before us at Toynbee Studios rather than spouting forth from the Jongleurs or Comedy Store stage. *Superjumbo* is not necessarily comic, not necessarily politically active, not necessarily even value for money, but there's still something to be said for the simple skill of being an engaging and instinctive communicator. Even in his pauses for thought, as he reaches for the next cue or tangent, Dedomenici has that skill in spades, allowing the audience to reach for their own cues and tangents. And in that sense I'm pleased to report that he's still an artist, despite all evidence to the contrary.

Review: Richard Dedomenici Superjumbo was originally published on Writing From Live Art, 15 June 2007. www.writingfromliveart.co.uk

Be Here Now

Adam E Mendelsohn on the ultimate high – the retrieval of history through re-enactment

It's difficult to tell whether Mark E Smith is celebrating or berating the inevitable when he blared: 'There's repetition in the music and we're never gonna lose it.' An averse reaction to being held hostage by the almighty laws of repetition might explain why most people who are really into art, are also addicted to rarefied experience. Art devotees are junkies that forever chase the new, the ancient, the authentic, the unique, the true, the weird, the exquisite, the beautiful, the priceless and the sublime. Perhaps the most ethereal, unobtainable 'high' is access to the past.

During the 90s, a handful of contemporary artists were making restagings or re-enactments as a way to gain further understanding of the present through the lens of the past. More recently, re-enactments – a hybrid of performance, theatre, folk art, Conceptual Art and video art – have gained momentum as a trend in contemporary art.

Just this summer Mass MoCA mounted a show titled 'Ahistoric Occasion' which is made up of work by artists 'exploiting the material of history to shape and give new meaning to the present' and includes work by Paul Chan, Jeremy Deller, Allison Smith and Yinka Shonibare among others. One work that stands out from the show is by Felix Gmelin who re-enacted his father's 1968 march through Berlin waving a communist flag – a fairly radical statement of protest and activism at the time, but which is rendered amusingly out of synch and silly today. Another statement of 60s protest and activism was revisited at this year's Whitney Biennial where Mark di Suvero and Rirkrit Tiravanija recreated the *Artists' Tower Against the War in Vietnam*, 1966. It is hard to imagine *Peace Tower*, which seems rather tame now, as ever having been thought of as controversial when it was originally erected. Both pieces are successful in demonstrating the shift in what is perceived as radical behaviour even when conditions throughout the world are arguably comparable. Although Gmelin's piece is performative and essentially video art – both pieces fundamentally rely on documentation, positioning archival material as the primary source for making this type of art.

Interrogating history is itself the acknowledgment that much of what we know and who we are as people and societies is dependent on second-hand, mediated accounts of the past. In 1980 Allan McCollum wrote, 'Again, we must question our everyday beliefs concerning how successfully we may know anything the evidence for which we receive by way of language, symbols, imagery, and so forth.' Eyewitness reports, written records and audio-visual materials combine to paint the most persuasive version of what really happened; something that is potentially always open to interpretation since we can never physically travel back in time (at least not yet) to witness what happened ourselves. Perhaps the popularity of historical re-enactments, weekend restagings of important battles by hobbyists, is because this is an activity that meshes history with fantasy and offers the next best thing to actually having been there – minus the real-life consequence of violence. Jeremy Deller employed just such re-enactors for his epic piece *The Battle Orgreave* in 2001.

In 2005, 'Life Once More – Forms of Re-enactment in Contemporary Art', curated by Sven Lutticken for Witte de With, Rotterdam, was one of the first group shows that recognised re-enactment as an established artistic project and included work by some of its major proponents, Rod Dickinson, Barbara Visser, Robert Longo and Andrea Fraser among others. Further, 'Life Once More' cited performance as a critical strategy for reinterpreting history: 'Performative art thus serves as a duplication and an interrogation of a nostalgic event culture; it becomes an attempt to fight repetition with repetition, to break open and recharge the past.' In particular, Dickinson has consistently made re-enactments of controversial moments in recent history. In his pieces *Jonestown Re-enactment*, 2000,

The Milgram Reenactment, 2002, and *Nocturn*, 2004, Dickinson uses reenactment as a way to confront history actively, making the past into a site or spectacle for viewing.

Dickinson has talked about history as a type of mind control. Although the works exist as films, and you could argue that what Dickinson ultimately produces is video art, the performative element – using an audience as witness and participant – is crucial to understanding the work. Intrinsic to *The Milgram Re-enactment* is the nature of Stanley Milgram's original experiment carried out at Yale University between 1960 and 1963 which examined forms of social obedience. Milgram's experiment relied on an artificial environment for the successful collusion of its participants. Milgram stated: 'With numbing regularity good people were seen to knuckle under the demands of authority and perform actions that were callous and severe. Men who are in everyday life responsible and decent were seduced by the trappings of authority, by the control of their perception, and the uncritical acceptance of the experimenter's definition of the situation.' *The Milgram Re-enactment* uses artifice as a means to illustrate what is essentially the goal of distinguishing the true from the false and draws a rather useful parallel with the enduring issues raised by representational and non-representational art.

Similarly, Artur Zmiljewski recreated social psychologist Philip Zimbardo's landmark 1971 Stanford Prison Experiment. Where in *The Milgram Reenactment* Dickinson was more concerned with documenting a live historical re-staging witnessed by an audience, Zmiljewski, in *Repetition*, 2005, was more interested in creating a historical simulation to test whether or not Zimbardo's original experiment could be successfully repeated today. Both pieces are simulations of simulations, but where *The Milgram*

Re-enactment faithfully reproduced the outcome of the original experiment, *Repetition* recreated the conditions of the original experiment which allowed for unscripted results. Shown in the Polish Pavilion at the 2005 Venice Biennale, Zmiljewski's *Repetition* is a remarkable example of the intersection where art meets real life and uses re-enactment to explore complex ethical issues and to weave a compelling narrative out of historical precedents; the evidence for which is anchored to archival materials.

The connection between historical re-enactment and ritualised violence is not a flimsy one. Robert Longo, cited by Ian Aitch in 'Doing it Again', has said: 'The whole idea of re-enactment, you can trace it back to the ritual of violence and sacrifice, tragedy and theater. Re-enactment is like mass in a church.' One of the things that Dickinson's work and Deller's piece *The Battle of Orgreave*, have in common is that they revisit violent moments in history. Deller became interested in historical re-enactment for its status as a kind of representational folk art, adopting it as a form to create *The Battle of Orgreave*. Filmed in June 2001, it was a live re-enactment of a violent dispute between picketing miners and the police at Orgreave in South Yorkshire. Some 800 historical re-enactors took part alongside locals, some of whom were involved in the actual confrontation in 1984. Broadcast on Channel 4 in 2002, the film met with varied responses but highlighted most successfully the way in which the participants were given a deeper insight into what took place through their participation in the re-enactment. A kind of cathartic, interactive theatre whose accuracy and effectiveness is nonetheless dependent on the mediated accounts of witnesses and the eye of a photographer or film director.

Many seminal moments in the history of performance art rely solely on photographs and oral accounts, from Yves Klein leaping from a window, Chris Burden shooting himself in the arm, to Marina Abramovi? inviting an audience to use surgical tools on her. The imperative of actually being there, to witness these performances first-hand, was addressed last year in Performa 05 where seminal performance art classics – works by Bruce Nauman, Vito Acconci, Valie Export, Gina Pane, Joseph Beuys and Abramovi? – were re-performed. The question of whether these one-off, past performances were devalued or shed some of their mythic status for being repeated demonstrates the link between event culture and nostalgia, a by-product of imagination, longing, eroded memory and educated guesswork.

Nostalgia, event culture, artifice, spectacle and fantasy all mesh together in Slater Bradley's video art. Central to Bradley's work is the integration of personal history with mediated, public histories. Specifically, Bradley has used archival footage of iconic rock stars Kurt Cobain and Ian Curtis to make performances. In *Factory Archives*, 2002, Bradley created a sort of bootleg video, casting an actor to play himself as lead singer Ian Curtis of post-punk band Joy Division. *Factory Archives*, which is a fictional video, has since been successfully absorbed by actual Joy Division archives. Essentially, what Bradley does is to create layers of uncertainty and competing fictions. Bradley's performances examine the anxiety of navigating lived experience versus hand-me-down experience, something Richard Prince called 'counterfeit memory'. Like Dickinson and Deller, Bradley's work rides a knife edge because it demonstrates how the fabrication of evidence, the manipulation of perception, and the construction of believable environments can create a kind of false credibility – a dangerous notion that threatens to topple faith-based systems. Hopefully, the work encourages us to approach history as a

living breathing thing, and that our acceptance of what we know requires us constantly to verify and confirm how we know what we know. All three artists' work articulates the fine line between falling prey to persuasive conspiracy theories that contest everything, even in the face of overwhelming evidence, and objective evaluation.

In 1998, the collaborative duo of Iain Forsyth & Jane Pollard made a live re-enactment of the last ever concert given by Ziggy Stardust, David Bowie's invented persona. For *A Rock 'n' Roll Suicide* the artists hired look-alike actors to play the band's original members. The re-enactment was filmed in front of a live audience and paid rigorous attention to minute detail. The actors literally duplicated the original performance move for move in order to portray a historically faithful replica of the original concert. What came dangerously close to a kind of elaborate Karaoke, a West End show and a fanatical tribute band, was also an illuminating exploration of artifice and nostalgia. *A Rock 'n' Roll Suicide* offered the audience keys to a moment locked away in time, by way of suspended disbelief and accurate representation. More profoundly, *A Rock 'n' Roll Suicide* addresses real-life idol worship, a love affair with images and fictions that are sucked out of the pages of magazines and TV sets and enacted through the uniforms and costumes of daily life. Following that, Forsyth & Pollard pushed it one step further by making a re-enactment of the legendary 1978 concert given by The Cramps to the patients of a mental hospital in California. For this piece, *File Under Sacred Music*, 2003, the artists became less interested in performing a re-enactment to a live audience, which emphasised the necessity of being there, and instead became more concerned with making an exacting replica of the original, grainy black and white video, that in their own words had a

quality of 'liveness'. The culmination of months of research and the same relentless devotion to detail, the re-enactment was filmed at London's ICA where patients from a nearby psychiatric hospital were invited to participate. What is compelling about this work, is the way it feels authentic and successfully reproduces the strange ambience of the original.

In many ways, Forsyth & Pollard's *File Under Sacred Music* shares the concerns of hyper-realist painters and sculptors like Ron Mueck, the Boyle Family, and conceptual artists that create sculptural facsimiles such as Justin Lowe, who recreated an extremely detailed New York Deli for his show at Oliver Kamm 5BE, and Elmgreen & Dragset, who recreated an 80s subway station complete with carefully researched, retro junk strewn across the tracks. Arguably, the work of Forsyth & Pollard is genealogically connected to 80s appropriation artists like Mike Bidlo and Sherrie Levine. But where appropriationists questioned ideas about authorship, originality, plagiarism, value and authenticity by making copies or repeats of well-known art works, artists that use re-enactment as a strategy leverage a greater degree of intervention, both conceptually and physically. Levine, who has exhibited watercolour copies of Mondrian paintings from reproductions, has said that she was more interested in reproducing 'the flavour of the book plate' than in making a perfect copy, which is similar to the 'liveness' that Forsyth & Pollard were interested in recreating for *File Under Sacred Music*. If there were ever an example of chinese- whispers-style narratives, it would be contemporary artist Dylan Stone's three-dimensional recreations of Levine's rephotographed versions of Eugène Atget's Parisian interiors – an example of art that aptly demonstrates the flow of fictions supported on questionable

foundations. But perhaps more than anyone, the work is indebted to the 40-year career of Sturtevant.

For most of her career, Sturtevant has been repeating works by some of the most important figures in art of the second half of the 20th Century. Exploring notions of the replica and simulacrum, the original and fake, Sturtevant has made repetitions of works by artists such as Marcel Duchamp, Andy Warhol, Anselm Kiefer, Frank Stella, Roy Lichtenstein, Claes Oldenburg, Joseph Beuys and Jasper Johns among many others. Central to the work is the artist's insistence that 'The brutal truth of the work is that it is not a copy' and that 'the dynamics of the work is that it throws out representation'. In 2004/05, Sturtevant exhibited some 140 works (sculpture, painting, drawing, photography, film and video) in the Museum für Moderne Kunst in Frankfurt which for the first time in its history devoted its entire exhibition space to her work.

Underpinning re-enactment art is the implication that the activity of making art itself, participating in cultural production, is itself a kind of historical re-enactment – an activity that preserves heritage through ritualised behaviour. Whether or not re-enactment art is dramatically different from every other film that comes out of Hollywood, or indeed different from the persistent goal of theatre in demarcating what remains relevant over time, is open to debate. Maybe re-enactments are simply tangible maps to imaginary places. The question of whether we are author of our own lives, or whether our lives are scripted will always be relevant and it might be that re-enactment is simply another way of approaching that question. Another possible reason that re-enactment is becoming a more frequent strategy for making contemporary art is that the analysis of re-enactments can yield viable solutions to present day problems.

In his introduction to the volume of essays *Excavating Modernism*, 1996, Bernard Tschumi writes: 'Ex-centric, dis-integrated, dis-located, dis-juncted, deconstructed, dismantled, disassociated, discontinuous, deregulated … de-, dis-, ex. These are the prefixes of today. Not post-, neo-, or pre-.' Granted, that was written ten years ago but I'm still at odds with that statement. Perhaps the most relevant prefix now is re-. Recycle, re-look, restage, re-think, re-build, return, re-make, re-wind, revolution, re-evaluate, re-charge, re-invention, repetition, or as Sturtevant said: 'Remake, reuse, reassemble, recombine – that's the way to go.'

Playback_Simulated Realities is at The Edith Russ Haus for media art, Oldenburg, Germany, September 3 to November 5 2006. **Silent Sound** by Iain Forsyth & Jane Pollard will be at St George's Hall in Liverpool on September 14 and Greenland Street, Liverpool from September 15 to November 26 2006. **Ahistoric Occasion: Artists Making History** is at Mass MoCA, Massachusetts until April 22 2007.

Be Here Now was originally published in Art Monthly, Issue 300, October 2006.
www.artmonthly.co.uk

Release from Clarence House

Live Art List members may be interested in the following writes **Chris Riding**

After two years of uncertainty, Clarence House has now revealed that Prince Harry has, in fact, been involved in a bespoke five year undercover operation as a cutting edge performance artist and self-styled 'art guerrilla'. In October 2004 such a statement would have seemed palpably absurd after claims made by his former art teacher at Eton that she had helped him to cheat in his O-level art exam. At the time many art world insiders had suspected the Prince was mounting a Chapman Brothers-style attack on the relationship between artistic intention and institutional judgement. The Chapman Brothers, it should be remembered, retook their art A-levels precisely to mount such a critique, even though they were enjoying critical and financial success as part of the Young British Art (YBA) movement and stood nothing to gain from re-sitting their school art exams. Indeed, speculation that the Chapmans were employed as Royal Art Tutors (RATs) has been whispered over Bellinis in the capital's most fashionable cocktail bars for a while. The preparation time for one of their exhibitions, *Works from the Chapman Family Collection*, which consisted of faux ethnographic carvings of African totems holding McDonalds hamburgers, suspiciously coincided with the Prince's trips to South Africa to shoot water buffalo and "work with local artisans". The Prince, who is known to be "handy with his fists", now seems to have provided much of the labour for the carving of these exquisite totemic parodies.

Clarence House may have been forced into revealing the true nature of the Prince's choice of vocation after a photograph of him dressed as a member of General Erwin Rommel's Afrika Korps, replete with a 'prominent' swastika armband had been published today in the English press. The photograph was taken at a 'Native and Colonial' fancy dress party given by the Olympic show jumper, Richard Meade, to mark the 22nd birthday of his son, also called Harry, and who is, also, a performance artist. His most recent 'action' involved invading the Labour Party Conference to campaign on behalf of the pro-hunt lobby. Clarence House made the following statement: "We can now reveal that Prince Harry has, over the past four or five

years, been working as a bespoke art guerrilla. His latest 'action' should be interpreted as a critique of Nazism and its aristocratic connections (i.e., referencing the political 'gestures' of King Edward VIII etc.). The Prince's current 'social sculpture' draws on the cultural legacies of Joseph Beuys, Gilbert and George as well as Sex Pistol, Sid Vicious, and the Punk clothing and attitude of Vivien Westwood and Malcolm Mclaren. As a scholar of Derridean deconstruction, the Prince is fully aware that 'meaning' is, at best, only ever deferred. It is precisely this knowledge that underpins the work's haunting bathos".

A spokesperson for London's leading art gallery, White Cube, confirmed that Prince Harry has been working on a 'major exhibition' over the last few years that had been pencilled in to open in the summer of this year. In this light, his actions over this time now seem not to be those of a buffoon but of an assiduous young man mounting a fervent critique of Blair's Britain. Seen in this way, his performance piece in October of last year (again) outside a London nightclub, where, "pissed up", he started a brawl with paparazzi photographers and narrowly avoided prosecution, now reads as a method acted critique of binge drinking and the current parliamentary debates on English licensing hours. As such, it clearly has a precedent in Gilbert and George's 1974 *Drinking Sculpture*. His ongoing use of marijuana, which spawned the infamous "Harry Pothead" monicker in the early stages of the performance, now reads as a deftly acted take on England's draconian drug laws in the style of the late Serge Gainsbourg with overtones of Vito Acconci. The untitled photographic self-portrait of an omnipotent Prince presiding over the carcass of a water buffalo whilst holding a hunting rifle with telescopic sights draws on the formalism of William

Eggleston's Kenyan photographs, whilst offering a devastating attack on colonialism and the culture of death. It is now understood that the water buffalo had been made from papier-mache. In addition, the rifle had been carved by a local artisan in exchange for a four-week 'celebrity-style lifeswap' at Buckingham Palace to coincide with the art guerilla's exhibition at White Cube. This will be webcast for the duration of the show. The spokesperson at White Cube also hinted at a further body of work that would reference Gilbert and George's various singing sculptures (where they stood, as living sculptures, on tables or plinths and sang old East End music hall songs). When Buckingham Palace took a direct hit during the Blitz in September 1940, the Queen Mother (gawd bless 'er, guv'nor) famously stated – "I'm glad. It makes me feel I can look the East End in the face". It is believed that, as part of the White Cube show, the Prince will undertake a walk in the style of Richard Long but dressed as one of Oswald Moseley's Blackshirts. Armed only with a fold-out table and a megaphone, he will stop at key areas in the East End that were bombed during the Blitz, stand on the table and quote the prose work of Moseley's vision of hatred through the megaphone. The White Cube exhibition, to be titled *Brother, Spare Me a Hate Crime* is to open later this year on the state birthday of the Queen.

Release from Clarence House was originally posted on the Live Art Discussion List, 17 January 2005.
'Chris Riding' appears to be a pseudonym and the editors have not been able to identify the source of the posting. www.jiscmail.ac.uk/lists/liveart.html

Exchange Places: The Memory of Desire and the Desire of Memory

Will Pollard

Prologue

A plane descends in a rain soaked sky. Gravity embraces the falling; clouds precipitate rain as memory insists loss. Leaves bent and rusty from gravity's rule circle the ground, a fading adoration of a past love. The trees have nowhere to hide; the concrete path, no wish to hide. An empty bandstand in song, rain, strings, clouds, horns, people, choir. The landing aeroplanes suggest a subliminal yet simultaneously dawning counterpoint in a pagan time signature. A woman dressed in black views us through viewing herself. Situated here and now, rain has melted all the dust of past; place syncopates experience to the counterpoint of memory.

Introduction

Being asked to write is like being presented with an empty box; being given an interior to explore and preset as exterior; yet finding within this nothingness a potentiality as vast and unique as nature. Space is serious and playful, one suggests two suggests three suggests then and now.

I wish to use this opportunity to explore a number of significant outcomes from *Exchange Places*, a festival of performance art that took place in Belfast between 25 and 28 of October 2006 organised by bBeyond, Belfast. The work was mainly presented in a multi-use space *The Black Box* situated on the corner of Hill Street and Exchange Place on the east edge of the city centre. The context was set; a group of performance artists from Quebec (and Canada) would visit Belfast and make a series of performances and a group of artists from Belfast (and the island of Ireland) would also show their work.

Accounting for the implicit failures and vagaries of memory and desire, this text can be nothing more than a personal account of experience… subject to itself. I wish not to make an exhaustive list of every performance and action that happened as part of the festival, but rather take individual performances, images and memories as starting points for elucidation and reverie. This text is interspersed with reflections on images, memories and the half-life of bodily experience; a memory of existing in the past-present of individual

performances. I also chose not to undertake a comparative analysis of artists work from Canada and Belfast, such demarcation and delineation runs counter to my experience of performance, as well as my reasons for writing.

Exchange Places
In a semi-circle resides an idea. An idea lives through itself as actuality, as time lives through space as experience. The mutability of experience which shoots through our being, is uniquely constellated in the actuality of performance. Around an axis of mercury turns ploughed field and a golden field of wheat. A fall season past reaches the turning point and returns to itself as green spring. Situated in relation to you, a face of paper turns to reveal the creases of my experience. Through the paper a texture of light reflects; an honest gift, openly displayed, concealing a fluid that already existed. It explores regions new, forgotten, essential.

A woman rubs the area around her mouth with blue water-soluble paint. In a vase full of water she places her face. Breath is held and water is displaced. As the water dilutes the paint, blue threads, strands and currents are made visible. If water could breathe it would expose its invisible currents in a blue of the ocean. The tension between inhalation and exhalation, between the systole and diastole of the heart; I am brought to a stillness outside of time and between space, where the threads, strands and currents of relation, of experience, are made visible. In this time past, a dawning present insists itself as interior and ripples as, not only what is essential to the present, but that which *is* the future. Memory is the signature of the past intimated and renewed through the present.

Owner Without Things
Possession of something necessitates ownership of nothing. Nowhere is this dual sense of apossession felt more strongly than in the experiential situation that is performance. A performance is not a static perceptual situation, neither is it a causal account of actuality; a performance is an experiential situation that implicates artist and audience, action and non-action, visible and invisible. In the flux of language, of experience; the relationship between entities of inter-being oscillate between the visible and the invisible. The hand of the visible reaches out to the invisible and in simultaneity finds itself invisible. In a crack of experience I found a world made of everything I had never thought.

The Innocent Moment and the Moment of Innocence
Being in, and of the world, insists a necessary learning and understanding from invisible and visible phenomena. An adaptation to that which is there and that which appears not, our conception of these dynamics is always a slippage from the truth of experience. There exists a fictitiousness at the depth of our experience of and in the world; unknown narratives write our lives from the outside in. In our perception of the relationship between the body and the world there is a cleavage between self and non-self, us and them, between question and answer. This cleavage is framed and encased within a clear membrane that reflects as a mirage the specific environmental light of its position in the world; a rainbow spilt and painted on the surface of an ever pulsating circle… a circle that is whole and burst in simultaneity, particle and wave, subject to the temperamentality and vagaries of existence.

This oscillation between the invisible and the visible is enacted and embodied in the relationship

between performer and audience. This interdependency breeds a shadow that arcs over performance as a cover and ceiling of a strange shelter. The architecture of the site and context constitutes the event as the interrelationship of the body of *that-which-is-experienced* constitutes site and context. Where is the distinction between the seeing and the seen, between known and unknown, between the invisible and the visible? The invisible is not the opposite of the visible; the invisible is the implicit potentiality of the visible that has yet to come into being.

As a space of knowing, of experience, of communality (with the event, others, and ones self) the performative act constructs an apparently temporary yet visceral flesh that houses that which lies beyond the dichotomy of subject and object. This locus of intentionality constitutes the performative event, whilst simultaneously and paradoxically *being* the event. Like desire and memory toppled in on each other, previously parallel and vertical, now embracing and resting on each others shoulder, the space between them is the dwelling of performance.

In the flux of the moment; in the presence and pressure of experience, a construction is made manifest; in contrast to the architectural monumentality of building; in contrast to the demands of the ego, this sensitive, fragile yet pervasive construction provides the foundation that is the very essence of performance. In this space between memory and desire, in the gesture of the past intimated and renewed through the present, a dwelling is exists that unfolds and enfolds experience.

Unfolded Time and Enfolded Space
Our presence and pressure in and of the world is characterised by a fold. Our self folds and rearranges in accordance with that which is not. The body folds to the world and world folds to the body, just as the letter is folded and sealed in an envelope.

Such folding is archetypical of return. An enclosure embarking on a requisite journey, from its enclosing it remembers (paradoxically) its future return. The fabric of our perception and the textural specificity of the world (and our presence as it) is constituted by an opening and a closing, systole and diastole, a coming and a going whose only desire is a return to itself, a return of the flesh of unfolded to the flesh of the enfolded.

Lying on an inflatable mattress with a snorkel attached, a performer breathes into the snorkel, and in-turn, into the inflatable bed. A moment is reached when the capacity of lungs is regulated with the volume of that which upon we lay. The inflation is automatically displaced by the weight of the body that rests upon the mattress. As an action of cyclicality, of the sent and of the return, the body performs a central role. The body is the axis around which the breath of the world turns. The body is the point at which the breath of the world returns.

An Invisible Touch
Touch is the cord that binds us to the world, though this cord also manifests from within. It is as if our bodies are a distension of touch. The primacy of touch combines with the primacy of breath; just as wind shapes the trees, so too touch shapes our bodies and experience of the world.

If I hold out the index finger of each of my hands in front of my eyes, and allow my eyes to go crossed eyed, and then bring the tip of each finger together and new double finger is created. What appears in the space between the fingers is a new finger that has the tip of my right finger and the tip of my left finger in simultaneity.

Vision is not monocular, I have two eyes that feel out toward the world. My eyes create a double finger that is attached to my hand. This new double finger extends into the space beyond the original finger. This *other* finger is an appendage of the ones attached to my hand, just as my breath extends beyond the corporeality that generated it, so too, this *other* finger reaches out into the world. The same phenomenon happens with my right index finger, as these two prosthetic fingers touch each other they create a double finger. These prosthetic fingers touch, who am I to say that they do not; as before my eyes (and *because* of my eyes) I am implicated in something beyond myself.

Touch is double and touch is return. This touch of return accounts for, yet goes beyond singular touch and manifests itself as an encounter. This encounter slips beneath the idea of touch, between the fingers of the visible, into a negative space of primary understanding and feeling.

Epilogue
In a bright space the performer stands. Two men with beards are asked to contribute to the performance. A piece of hair from each is cut and placed in a drink. A wire connects them together; connects them to the performer. They are invited to drink. The wire that links them all is connected to a microphone, articulating every movement of the space. Their body became sound; our bodies are sound... forever sounding... together.

Exchange Places **Participants**

Francis Arguin	Maebh McDonnell
Julie Bacon	Justin McKeown
Annie Brunette	Christian Messier
Colm Clarke	Hugh O'Donnell
Leo Devlin	Sinead O'Donnell

E. Factor	Francis O'Shaughnessy
Mick Fortune	Brian Patterson
Hilary Gilligan	Will Pollard
Elina Hartzell	Peter Richards
Alejandra Herrera	Anne Seagrave
Poppy Jackson	Dan Shipsides
J. King	Julie Andree T
Aileen Lambert	Mark Ward
Richard Martel	

The Memory of Desire and the Desire of Memory was commissioned by Bbeyond and will be published in 2008. Will Pollard is an artist and writer based in Cheshire. www.bbeyondperformance.org

Ethno-techno: Writings on Performance, Activism, and Pedagogy by Guillermo Gómez-Peña, edited by Elaine Peña

Leslie Hill

Reading Guillermo's latest book really made me want to be a performance artist. Happily, I already am one, and yet I feel somehow born again in the tight piquant prose. This collection offers an unprotected fluid exchange of ideas and cross-contamination of methodologies, a coyote blood transfusion, a brujo skin graft, an Aztec defibrillation. The buzz it will give you will cost you less than a pack of Marlborough reds and a bottle of Myers rum and it will last a whole lot longer. It might even change your life. Apart from the obvious kick of getting to look at lots of bare-chested photos of Guillermo, I feel revitalized in the complexity of my calling. I suspect I would feel the same rush after reading this book if I were a political activist or a pedagogue. It's not easy to juggle all three things at once (performance, activism, and pedagogy) and yet so many of us are trying our best to do just that … with mixed results. On bad days or at the end of really gruelling touring seasons, the combo can make you feel like a knackered performer, a half-ass activist and a distracted workshop leader parachuting in on local groups and then wondering

where am I and who are these people? Yet, as Guillermo reminds us, the three things can work together beautifully. We need to hear it.

The book is divided into five 'tracks', the first of which introduces Guillermo Gómez-Peña's unique hybrid role as an interdisciplinary intellectual, an experimental cartographer, a lost shaman, an antihero, a provocateur, and a reverse anthropologist who offers performative strategies for freeing the straightjackets of fixed identities. This introductory track poses questions about our changing roles as artists and intellectuals in the post 9/11 'cartography of terror'. In the introductory essays Gómez-Peña addresses many contemporary concerns of performance and the world at large. He defends the body-in-action of the performance artist as irreplaceable by actors, robots or avatars. He points out some of the new challenges posed to artists and curators by audiences of the SuperNintendo generation who want to engage actively, interactively with art works. He draws a distinction between artists and theorists: 'We theorize about art, politics, and culture, but our interdisciplinary

methodologies are different from those of academic theorists. *They* have binoculars; *we* have radars' (21). He suggests a Free Art Agreement for North America as a preferable alternative to NAFTA. He credits the Bush administration with inadvertently repoliticizing art by attacking the core values of art practices in his 'war on terror'. His essay 'In Defence of Performance' (2003) should be on the syllabus of every performance studies course and should definitely replace Gideon Bibles in the drawers of every hotel room used by performance artists on tour. What performance artist doesn't need to hear this after a couple of months on the road: 'Deep inside I truly believe that what I do actually changes people's lives, and I have a real hard time being cool about it. Performance is a matter of life and death to me' (28).

The second track of the book is 'Pedagogy: a Useful Guide to the Pocha Method'. This is perhaps the most exciting section of the book because it offers the reader a glimpse into a process that only workshop participants have known previously. Furthermore, this is the section of the book where Gómez-Peña has a heartfelt epiphany about the importance of pedagogy: 'the actual methodological process of developing original material (as outlined in this book) might be the most politically transgressive and hopeful aspect of the work. In other words, the process itself is actually becoming the ultimate "project" for us' (135).

We all loved him before, but who wouldn't kill to get into one of his workshops now – who doesn't long to enter the 'demilitarized zone and nerve centre for progressive thought and action'(96)? Co-authored with Rachel Rogers this section of the book documents a unique on-going process of stimulating, challenging, mentoring, co-creating as well as offering up a bounty of ideas for artistic 'homework' and performance workshops that I'm sure will be widely used. The utopian spaces created within the contexts of these working groups are described in the introduction as, 'framed by, but not contained within a pentagon-shape of radical ideas whose vertices are community, education, activist politics, new technologies and experimental aesthetics' (xxv). The obvious generosity with which Pocha Nostra involves local artists in their work through workshops and final performances is truly inspiring and this section of the book perfectly reflects the Pocha Nostra model of recurring segues from voyeuristic to participatory: we are given a window into Pocha Nostra's working methods and we are invited to use them.

Tracks Three and Four of the book include performance scripts from radio, stage and cyberspace, including radio pieces from 1999 to 2003 such as 'My Evil Twin' and 'Saddam in Hollywood'. These performance literature tracks, along with the rest of the book, are peppered with photographs of performance *tableaux vivants* with captions like, 'Mexican Artists in Search of Aggressive US Curator to Domesticate Them'. For those of us lucky enough to have seen some of these pieces or versions of them live, the chance to be able to read and savour the printed text is like the pleasure of buying the Patti Smith album after the concert and indulging in the repetition of favourite tracks and slowly savouring some of the lyrics.

> *If only I had a decent command of English*
> *when I got involved with my past lovers.*
> *If only I had known the difference*
> *between jerk around and jerk off,*
> *between napkin and kidnap,*
> *between prospect and suspect*
> *between embarrassed and embarasada.*

If only I had known the difference
between desire and redemption
between political correctness and personal
computers
between us and US
between humanity and mankind
We've only got one word for both in Spanish:
Humanidad, perdóname por ser tan bi-rollero
If only I had known the difference
between loneliness and solitude…
We've only got one word en español:
Soledad. (196-197)

The 'Border Blessing' and 'Brownout 2', written largely while Gómez-Peña hovered near death in hospital in Mexico City in 2000, are powerful and emotive texts. They made me cry even though I read them sitting on a pebble beach on a sunny day with hooligan toddlers throwing rocks at my head. As well as offering versions of his own performance scripts, Gómez-Peña offers the 'layperson' performance strategies for real life. In order to avoid misled racist attacks, for example, he advises 'all Arab-Americans should wear a mariachi hat and a Mexican zarape when going out in public' (235).

The final track of the book is 'Conversations with Theorists' which confirms that not only can Gómez-Peña write and perform in English better than most native speakers, he is also bi-lingual in artist / academic lingo. As well as expressing a genuine regard for theoreticians and for rigorous dialogues between theoreticians and artists, Gómez-Peña poses a humorous but serious challenges to scholars: 'how can you reconcile the fact that radical theoreticians are presenting two-hour long papers dealing with radical ideas in the most traditional and authoritative way, standing behind a lectern under neon light in horrible rooms at nine in the morning'

(267). Gómez-Peña also challenges artists to explore more intellectual avenues, which is all part of the spirit of interconnectivity between performance, activism and pedagogy that make this a great book.

Ethno-techno: Writings on Performance, Activism, and Pedagogy by Guillermo Gómez-Peña, edited by Elaine Peña was originally published in Contemporary Theatre Review 17 (1) 2007.
Ethno-techno: Writings on Performance, Activism, and Pedagogy is published by Routledge.
www.informaworld.com

Letter from Oaxaca: Performing in the Flames

Guillermo Gómez-Peña

Opening day arrived, and while we were setting up in the Museum, 50,000 citizens had gathered outside to support the teachers. The sound of their loudspeakers intertwined with the sound of our rehearsal.

Dear friends:

On August 1st, my performance art troupe La Pocha Nostra began our annual 'summer school' in the Mexican city of Oaxaca. Each summer we conduct two intensive workshops, one for 'beginners' and another for seasoned performance artists. The result is a public performance at MACO (Museum of Contemporary Art, Oaxaca). Artists come from as far away as Canada, the US, the UK, Spain, Holland, Australia, and Peru to collaborate with indigenous Oaxacans working in experimental art forms.

The workshop is an amazing artistic and anthropological experiment – how do artists from different countries spanning three generations, from every imaginable artistic background, begin to negotiate a common ground? Performance art has

provided the answer, becoming the connective tissue and lingua franca for our temporary community. But this year the usual cross-cultural borders and dilemmas we regularly face multiplied in all directions. The gorgeous bohemian city had become center stage for one of the most intense political conflicts in contemporary Mexico, a nation on the verge of total collapse.

I'll be more specific.

On May 22nd the Teacher's Union (section 22 of the SNTE), who had been demanding a small raise in teachers' salaries, began an indefinite occupation (planton) of downtown Oaxaca. The government responded with a violent police assault in which, on June 14th, several teachers were wounded. The APPO (Asociación Popular de los Pueblos de Oaxaca) immediately joined the Teacher's Union and together they expanded the planton and took over the Canal 9 TV station, two radio stations, and several government buildings, blocking the main avenues and freeways surrounding the city. Los maestros were now demanding the destitution of Governor Ulises Ruiz, a repressive politician from

the old PRI guard, as well as the release of all the political prisoners the governor had jailed. Over the month of July the movimiento magisterial grew to encompass over 40 political, social and cultural organizaciones and 50 ONGS (non-profits) from throughout the state, including student associations, universities, art collectives and indigenous comunidades autónomas.

The tactics of the government shifted as well. By the time my colleague Roberto Sifuentes and I arrived in Oaxaca (July 29th), government hit-men had carried out 38 political assassinations and several teachers had been sequestered. The city felt like Belfast or San Salvador in the late 80s. Thuggish paramilitaries and porros (infiltrators posing as teachers) hired to create mayhem were roaming around, every wall was covered in graffiti and the government was cowardly operating in absentia.

In this highly volatile environment we continued our daily performance workshops in the studio of artist Demian Flores, located in Jalatlaco, one of the oldest barrios of Oaxaca. The participating artists (15 in the first workshop and 20 in the second) were all extremely brave and committed to their practice. Before workshop hours they would walk the city, talk to people, observe, sketch, and write notes. Despite the unnerving daily rumors, never did they express any fear or desire to leave. Word from the street and from local colleagues was extremely worrisome: 'Tomorrow we are expecting violence;' 'The governor (in hiding) is asking all foreigners not to leave their hotels today;' 'Flights might be cancelled indefinitely.' Each morning before we started teaching Roberto and I got together to discreetly discuss possible contingencies. What if someone was arrested? After considering the possibilities our advice was 'Be cautious but open. Be active observers but don't get too involved

because you might get deported. (Foreigners are not allowed to get involved in national affairs.) After all, our artwork is our way to be part of it all.'

Outside the planton area a strange normalcy pervaded which, paired with habitual cultural tenderness, characterizes Oaxaca. Occasionally this tender normalcy would be disturbed by a burning bus (the porros were constantly setting city buses on fire) or a passing SUV filled with paramilitaries with submachine guns, or the unmistakable sound of a gun shot mixed with the fireworks of a nearby pilgrimage. Life went on in a high intensity mode…not unlike performance art.

One day, during one of the many marchas (peaceful demonstrations), the teachers were ambushed by police snipers. One man was killed and several wounded. The next day the teachers carried the corpse in front of a ritual pilgrimage across the streets of the city. We were immediately reminded of the Gaza strip.

The questions infusing the workshop exercises and improvisations were strangely analogous to our political predicaments: Which are the borders we can/must cross? Where are the ethical/political limits of art? Should we be participants or chroniclers? What is our new relationship to the civic realm? What are the new characteristics of our ever changing multiple communities? Where do we belong when our alliances are not with the nation/state?

Inevitably the performance material we developed unconsciously revealed the frailty and danger of our immediate universe. It revealed the discreet fears stoically harbored by our psyches: beautiful images and actions of a world in turmoil where political violence and cultural perplexity intertwined with religious imagery. It contained physical metaphors of a world in transnational flux

where the global mediascape (the war on terror, the culture of high security, the Muslim/Christian conflict, etc) overlapped with the surrounding social reality. It unearthed shared images of hope and despair, of solidarity and orphanhood. It was as if we were dreaming collectively and, on occasion, having a collective nightmare.

We were like needy children clinging to one another. At night we would eat together, dance at El Central or have a drink at a hipster bar. Perhaps the only ritual undisturbed by the omnipresent crises was bohemia. At night, Oaxacans were as motivated as ever to dance, drink and laugh their way out of apocalypse … and so were we. One Friday night we couldn't enter El Central because the porros had burned a city bus right in front of the bar, but the next day Willy, the owner, reopened as if nothing had happened. The late night separation was the hardest. Walking back to our hotels amidst bonfires and buses blocking the streets was surreal. Not knowing if those shadows in the corner were teachers or porros was unnerving, but after a week it all became part of the strange normalcy.

If someone from the workshop didn't show up one morning, my colleagues and I would freak out and one of us would go immediately to their hotel to make sure they were safe. Near the end of the second workshop, Marietta, our producer, told us, in reference to MACO (the museum that would host our public performance in a few days) 'There is word in the streets that all cultural institutions might be taken over tomorrow, so we may not even have a museum…then what?' The group response warmed my heart. 'No problem. If that happens, we will find another space, refurbish it overnight, and have our performance there.' We were beginning to sound more and more like the Oaxacan civil society.

Opening day arrived, and while we were setting up in the Museum, 50,000 citizens had gathered outside to support the teachers. The sound of their loudspeakers intertwined with the sound of our rehearsal. It was extremely humbling and many times during that day I was stricken with doubts. Should we cancel the performance? Was it appropriate for the show to go on? But I quashed my doubts. At 7:30 pm, just as the demonstration ended, we opened the museum doors, and to our surprise, hundreds of people began to storm in. A perplexed museum employee said to me, 'Maestro, why would all these people (over a thousand citizens) come to experience weird performance art and experimental video on such a day?' Precisely, I thought.

There couldn't have been a better time for us to be there. It is precisely in times of acute crisis that cultural institutions become true sanctuaries for freedom of the imagination, that the function of art becomes clarified. The wide-eyed audience, which included many of the victims of the conflict, couldn't have been more playful or more interested in our bizarre imagery and actions. Art clearly brought them to another place, a parallel reality were symbols, metaphors and rituals attempted to make sense out of the political maelstrom we were all experiencing.

By midnight, we were politely forcing the audience out of the museum. They simply wouldn't leave. Alone finally in one of the huge colonial patios of the museum, the artists hugged each other and cried. With our make up smeared, we went to eat in silence. No one wanted to talk.

Today, August 20th, as I pack my suitcase, I'm thinking about the ineffable relationship between art and politics and how sometimes we just don't have the luxury to separate them, period. I'm also thinking about the bravery of the teachers defying

the government and of the artists who participated
in this amazing adventure with my troupe. In a few
hours I will be flying back to the US, a place under a
different kind of siege, where the citizenry is either
sleeping, or scared shitless (regardless that they are
unable to talk back to their politicians in the way
Oaxacans do), a place where artists are being
censored and feel inconsequential, a place that rarely
looks South, an isolated country I paradoxically
chose as my second home for the opposite reasons. I
am worried about my Oaxacan friends. I already
miss my new colleagues. It will be extremely
difficult for me to return to the existential ambiguity
and political complacency of San Francisco.

Guillermo Gómez-Peña
Oaxaca City
August 20th, 2006

Postscript: As I flew back to the US, the teachers took
over 12 out of the 13 commercial radio stations in the
city, and installed 500 barricadas throughout the city.
By the time this letter circulates in cyber-space, the
political situation will certainly be much worse for
them.

Letter from Oaxaca was originally circulated as an email
from Guillermo Gómez-Peña on 20 August 2006.

Artists are now taking the lead politicians have failed to give

Madeleine Bunting

At first, Antony Gormley's figures are barely recognisable. They seem so implausible, perched on precarious edges, tiny in comparison with the huge buildings on which they stand, dwarfed by the flags, spires and aerials that crowd London's skyline. Passers-by stand there, staring at the rooftops and the sky, pointing them out. It's their very quiet unobtrusiveness that haunts the mind for days.

Gormley has done it again. He has used castings of his own naked body to provoke national conversations about big questions – about the meanings of places as disparate as the north-east region, a Merseyside beach and London, and about our place in them.

Despite initial scepticism, the Angel of the North in Gateshead and Another Place at Crosby Beach have both been hugely powerful in redefining a place and attracting popular support. His London figures, Event Horizon, which opened last week, looks set to match his earlier successes. Will he ever be allowed to take these figures down?

Meanwhile another hugely popular artist, Andy Goldsworthy – whose work could not be more different – has an exhibition at the Yorkshire Sculpture Park near Wakefield that is attracting such crowds that the organisers have put out a plea for visitors to avoid the bank holiday weekend. The critics may sniff at both Gormley and Goldsworthy (some do so very loudly) but when has art ever been this popular?

The boom years for contemporary visual arts just keep rolling on – London's commercial art market is second only to New York – but it's about much more than the elite world of collecting. It's about how central a role art now plays in the public realm. No one needs convincing any more. Leftwing local authority council leaders, property developers – these were the types that once dismissed art as an unnecessary and frivolous accessory to the business of relieving poverty or making money. Now both constituencies are falling over themselves to commission that Gormley factor. Council leaders talk as earnestly these days about "place shaping" and the "narrative of place", as they once did about fighting job cuts.

But the very success of visual artists, facilitated by the generous funding they've enjoyed since 1997, is putting them under new pressure. Now that they have such a popular, well funded place in the public square, what do they have to say? What do we expect of them? Are they just a form of entertainment to delight and surprise us with unexpected invention (slides in Tate Modern for example) or is it rather that we want them to be saying something weightier, providing insight into ourselves and the conditions of our time? Artists now get lumbered with expectations that in other cultures might fall to shamans, preachers or prophets – or once fell to politicians.

What inflates these expectations of artists is a frustrated desire for change, and an equally profound sense of confusion as to how to effect that change. Over the last decade, art has scored some striking triumphs on this score: Marc Quinn's statue of Alison Lapper pregnant in Trafalgar Square arguably did more to challenge images of disability and beauty than the most carefully constructed anti-discrimination legislation. The Angel of the North's aspirational optimism helped overturn the reputation derived from two decades of industrial decline and demoralisation. Our understanding of how art can bring about certain key aspects of change has increased: it can transform reality by inspiring the imagination. At the same time, our disillusionment with the capacity of the political process to change behaviour has deepened.

Art can never do the messy business of politics – the negotiation and compromise. But politicians are now grappling with a new politics about how to change the way people behave in their private lives: how they eat, travel, shop, exercise, drink. And art can open minds and change hearts in a way that our politics is singularly failing to do.

Art is not about the simple certainties of political soundbites. It engages emotionally, prompting a self-questioning. There is no predetermined answer. As Gormley puts it: "The beholder has a share in the giving of significance to a work." The passer-by can interpret Gormley's figures on the skyline just as the art critic and the artist can: art is about opening up conversations and connections in a myriad of ways, even between strangers on the street who share their delight – or contempt.

In contrast, politics has been professionalised and managed down to the last detail. There is no room for risk. A Radio 4 Today interview is often about testing out the political skills of evasion and unflappability. We are not being provoked to reflect, but to witness a gladiatorial contest of wits. The consequence is that some of the most fraught political controversies of our time are migrating into art. In the case of Mark Wallinger's State Britain, this is literally true. One of the entries on this year's Turner prize shortlist – which is billed as the most political ever – State Britain is a re-assembly of more than 600 of the posters and objects of the anti-war protester Brian Hawes that were forcibly removed from Parliament Square in 2006. Now they're sitting in an art gallery.

Another recent example is the Iraq war. After the failure of the political process either to prevent the war or to call to account anyone for its prosecution and subsequent development, art appears to be the only vehicle left by which to express the anxiety and unease. Steve McQueen's work, Queen and Country, in Manchester, depicts 98 of the British servicemen and women who have been killed. This week a new ICA exhibition opens of proposals from 25 artists from around the world for a memorial to the Iraq war.

But the biggest challenge of all to artists is the environment. There is growing pressure on artists to use their new-found authority and audiences – prized assets not available to politicians – to increase awareness of our environmental emergency. Gormley's figures, with their references to the human race's ecocide, are looking over to the National Theatre flytower, seeded in grass that will flourish and slowly die back over the next six weeks: two installations in conversation across the banks of the Thames. If art has the power to shift engrained habits of mind, if it can prise open the apathy and indifference that is deaf to campaigners, scientists and politicians, then it must be enlisted, insists Matthew Taylor, director of the Royal Society of Arts, which is launching its big programme on the arts and ecology next month.

There have been plenty of instances of highly political art in the past – Picasso's Guernica, for example – but the crisis of political engagement leaves a vacuum that people turn to art to fill. Art has never had such political expectations thrust upon it. Is that good for the planet and good for art – or good for neither because it reduces art to agitprop?

Taking the Lead was originally published in the Guardian Newspaper on 21 May 2007. Copyright Guardian News & Media Ltd 2007.
www.guardian.co.uk

The Live Art Almanac

Politics in an Age of Fantasy

If progressives want to be a meaningful political force in the 21st century we need to start dreaming, argues **Stephen Duncombe**

REALITY, FANTASY AND POLITICS

In the autumn of 2004, shortly before the US presidential election and in the middle of a typically bloody month in Iraq, the *New York Times Magazine* ran a feature article on the casualty of truth in the Bush administration. Like most *Times* articles, it was well written, well researched, and thoroughly predictable. That George W Bush is ill informed, doesn't listen to dissenting opinion, and acts upon whatever nonsense he happens to believe is hardly news. (Even the fact that he once insisted that Sweden did not have an army and none of his cabinet dared contradict him was not all that surprising.) There was, however, one valuable insight. In a soon-to-be-infamous passage, the writer, Ron Suskind, recounted a conversation between himself and an unnamed senior adviser to the president:

> The aide said that guys like me were "in what we call the reality-based community," which he defined as people who "believe that solutions emerge from your judicious study of discernable reality." I

nodded and murmured something about Enlightenment principles and empiricism. He cut me off. "That's not the way the world really works anymore," he continued. "We're an empire now, and when we act, we create reality. And while you are studying that reality – judiciously, as you will – we'll act again creating other new realities, which you can study too, and that's how things will sort out. We're history's actors ... and you, all of you, will be left to just study what we do."

It was clear how the *Times* felt about this peek into the political mind of the presidency. The editors of the Gray Lady pulled out the passage and floated it over the article in oversized, multi-colored type. This was ideological gold: the Bush administration openly and arrogantly admitting that they didn't care about reality. One could almost feel the palpable excitement generated among the *Times*' liberal readership, an enthusiasm mirrored and amplified all down the left side of the political spectrum on computer listservs, call-in radio shows, and print editorials over the next few weeks. This proud

assertion of naked disregard for reality and unbounded faith in fantasy was the most damning evidence of Bush insanity yet. He must surely lose the election now.

What worried me then, and still worries me today, is that my reaction was radically different. My politics have long been diametrically opposed to those of the Bush administration, and I've had a long career as a left-leaning academic and a progressive political activist. Yet I read the same words that generated so much animosity among liberals and the left and felt something else: excited, inspired ... and jealous. Whereas the commonsense view held that Bush's candid disregard for reality was evidence of the madness of his administration, I perceived it as a much more disturbing sign of its brilliance. I knew then that Bush, in spite of making a mess of nearly everything he had undertaken in his first presidential term, would be reelected.

How could my reaction be so different from that of so many of my colleagues and comrades? Maybe I was becoming a neocon, another addition to the long list of defectors whose progressive God had failed. Would I follow the path of Christopher Hitchens? A truly depressing thought. But what if, just maybe, the problem was not with me but with the main currents of progressive thinking in this country? More precisely, maybe there was something about progressive politics that had become increasingly problematic. The problem, as I see it, comes down to reality. Progressives believe in it, Bush's people believe in creating it. The left and right have switched roles – the right taking on the mantle of radicalism and progressives waving the flag of conservatism. The political progeny of the protestors who proclaimed, "Take your desires for reality" in May of 1968, were now counseling the reversal: take reality for your desires. Republicans were the ones proclaiming, "I have a dream."

Progressive dreams, and the spectacles that give them tangible form, will look different than those conjured up by the Bush administration or the commercial directors of what critic Neil Gabler calls *Life, the Movie*. Different not only in content – this should be obvious – but in form. Given the progressive ideals of egalitarianism and a politics that values the input of everyone, our dreamscapes will not be created by media-savvy experts of the left and then handed down to the rest of us to watch, consume, and believe. Instead, our spectacles will be participatory: dreams the public can mold and shape themselves. They will be active: spectacles that work only if people help create them. They will be open-ended: setting stages to ask questions and leaving silences to formulate answers. And they will be transparent: dreams that one knows are dreams but which still have power to attract and inspire. And, finally, the spectacles we create will not cover over or replace reality and truth but perform and amplify it. Illusion may be a necessary part of political life, but delusion need not be.

Perhaps the most important reason for progressives to make their peace with the politics of dreaming has little to do with the immediate task of winning consent or creating dissent, but has instead to do with long-term vision. Without dreams we will never be able to imagine the new world we want to build. From the 1930s until the 1980s political conservatives in this country were lost: out of power and out of touch. Recalling those days, Karl Rove, George W Bush's senior political adviser, says: "We were relegated to the desert." While many a pragmatic Republican moved to the center, a critical core kept wandering in that desert, hallucinating a political world considered fantastic by postwar standards: a preemptive military, radical tax cuts, eroding the line between church and state, ending

welfare, and privatizing Social Security. Look where their dreams are today.

PARTICIPATORY SPECTACLE

All spectacle counts on popular participation. The fascist rallies in Japan, Italy, and Germany; the military parades through Moscow's Red Square; the halftime shows at the Super Bowl – all demand an audience to march, stand, or do the wave. Even the more individualistic spectacle of advertising depends upon the distant participation of the spectator, who must become a consumer. But the public in both fascist and commercial spectacles only participates from the outside, as a set piece on a stage imagined and directed by someone else. As Siegfried Kracauer, a German film critic writing in the 1920s about "the mass ornament," the public spectacles that prefigured Nazi rallies, observed, "Although the masses give rise to the ornament, they are not involved in thinking it through."

Ethical spectacle demands a different sort of participation. The people who participate in the performance of the spectacle must also contribute to its construction. As opposed to the spectacles of commercialism and fascism, the public in an ethical spectacle is not considered a stage prop, but a co-producer and co-director. This is nothing radical, merely the application of democratic principles to the spectacles that govern our lives. If it is reasonable to demand that we have a say in how our schools are run or who is elected president, why shouldn't we have the right to participate in the planning and carrying out of spectacle?

A participatory spectacle is not a spontaneous one; an organizer… needs to set the stage for participation to happen. But the mission of the organizer of an ethical spectacle differs from that of other spectacles. She has her eyes on two things. First is the overall look of the spectacle – that is, the

desires being expressed, the dreams being displayed, the outcome being hoped for. In this way her job is the same as the fascist propagandist or the Madison Avenue creative director. But then she has another job. She must create a situation in which popular participation not only can happen but *must* happen for the spectacle to come to fruition.

The theorist/activists of the Situationists made a useful distinction between spectacle and situation. The spectacle they condemned as a site of "nonintervention"; there was simply no space for a spectator to intervene in what he or she was watching because it demanded only passivity and acquiescence. The Situationists saw it as their mission to fight against "the society of the spectacle," but they also felt a responsibility to set something else in motion to replace it. "We must try and construct situations," their master theorist Guy Debord wrote in 1957. These "situations" were no less staged events than fascist rallies, but their goal was different. The Situationists encouraged people to *dérive* – drift through unfamiliar city streets – and they showed mass culture films after "detourning" the dialogue, dubbing the actor's lines to comment upon (or make nonsense of) the film being shown and the commercial culture from which it came. These situations, it was hoped, would create "collective ambiances," which encouraged participants to break out of the soporific routine of the society of the spectacle and participate in the situation unfolding around them: to make sense of new streets and sights, look at celluloid images in a new and different way, and thereby alter people's relationship to their material and media environment. As Debord wrote: "The role played by a passive or merely bit-playing 'public' must constantly diminish, while that played by those who cannot be called actors but rather, in a new sense of the term, 'livers,' must steadily increase." Whereas

The Live Art Almanac

actors play out a tight script written by another, "livers" write their own script through their actions within a given setting. The ideal of the "situation" was to set the stage for "transformative action."

TRANSPARENT SPECTACLE

Spectacle needn't pass itself off as reality to be effective in engaging the spectator. At least this was the hope of the playwright Bertolt Brecht. Brecht was disturbed by what he saw of the theater that surrounded him in Germany between the wars. With most theater (and movies and TV) the goal is to construct an illusion so complete that the audience will be drawn away from their world and into the fantasy on stage. This seduction is essential to traditional dramaturgy. First theorized by Aristotle in his *Poetics*, it stresses audience identification with the drama on stage: when an actor cries, you are supposed to cry; when he triumphs, you triumph as well. This allure is aided by staging that strives toward realism or captivates the audience with lavish displays of full-blown fantasy… Such drama "works" insofar as the audience is well entertained, but there is a political cost. Entranced, the audience suspends critical thought, and all action is sequestered to the stage. A "cowed, credulous, hypnotized mass," Brecht described these spectators, "these people seem relieved of activity and like men to whom something is being done. It's a pretty accurate description of the problem with most spectacle.

As a progressive, Brecht was horrified by this response of the theatergoing audience. He wanted to use his plays to motivate people to change the world, not escape from it. He understood that no matter how radical the content of his plays might be, if his audience lost itself in the illusion of his play and allowed the actors to do the action for them,

then they would leave their politics up on the stage when the play was over.

Brecht believed that one could change the way drama is done and thus change its impact on the audience. Borrowing from the Chinese stage, he developed a dramaturgical method called epic theater. Central to epic theater was the *Verfremdungseffekt*, a term he mercifully shortened to the V-effect, which, translated into English, means roughly "alienation effect." Instead of drawing people into a seamless illusion, Brecht strove to push them away – to alienate them – so that they would never forget that they were watching a play.

To accomplish the V-effect, Brecht and others, notably the Berlin director Erwin Piscator, who staged many of Brecht's plays, developed a whole battery of innovative techniques: giving away the ending of the play at the beginning, having actors remind the audience that they are actors, humorous songs which interrupt tragic scenes, music which runs counter to mood, cue cards informing the audience that a scene is changing, stagehands appearing on stage to move props, and so on. Brecht even championed the idea of a "smokers' theater" with the stage shrouded in thick smoke exhaled by a cigar-puffing audience – anything to break the seamless illusion of traditional theater.

While the function of the V-effect was to alienate his audience, it is a misreading of Brecht's intentions to think that he wanted to create a theater that couldn't be enjoyed. Nothing could be further from his mind. He heaped ridicule on an avant garde who equated unpopularity with artistic integrity and insisted that the job of the dramaturge is to entertain, demanding that theater be "enjoyable to the senses." For both political and dramaturgical reasons he rejected the preaching model of persuasion; he wanted his audiences to have fun, not attend a lecture. Deconstructing the mind/body

binary, Brecht believed that one could speak to reason and the senses. One could see through the spectacle and enjoy it nonetheless: a transparent spectacle.

Brecht's V-effect has been adopted, in some cases quite consciously, by some of the more theatrical activist groups. Recall the Billionaires for Bush. Wearing long gowns and tiaras, tuxedos and top hats, the activists playing billionaires don't hope to pass themselves off as the real thing. Real billionaires wear artfully distressed designer jeans; these Billionaires look like characters out of a game of *Monopoly*. Because their artifice is obvious, there is no deception of their audience. They are not seen as people who are, but instead as people who are presenting. Because of this the Billionaires' message of wealth inequality and the corruption of money on politics is not passively absorbed by spectators identifying with character or scene, but consciously understood by an audience watching an obvious performance.

Furthermore, the spectacle the Billionaires present is so patently playacted, so unnatural, that the absurd unnaturality of a caucus of "people of wealth" advocating for their own rights is highlighted. This is, of course, what American democracy has become: a system where money buys power to protect money. This is no secret, but that's part of the problem. The corruption of democracy is so well known that it is tacitly accepted as the natural course of things. One of the functions of the V-effect is to alienate the familiar: to take what is common sense and ask why it is so common – as Brecht put it: "to free socially conditioned phenomena from that stamp of familiarity which protects them against our grasp today." By acting out the roles of obviously phony billionaires buying politicians for their own advantage, the Billionaires encourage the viewer of their spectacle to step back

and look critically at the taken-for-grantedness of a political system where money has a voice, prodding them to question: "Isn't it really the current political system that's absurd?" The transparency of the spectacle allows the spectator to look through what is being presented to the reality of what is there.

Unlike the opaque spectacles of commercialism and fascism, which always make claims to the truth, a progressive spectacle invites the viewer to see through it: to acknowledge its essential "falsity" while being moved by it nonetheless. Most spectacle strives for seamlessness; ethical spectacle reveals its own workings. Most spectacle employs illusion in the pretense of portraying reality; ethical spectacle demonstrates the reality of its own illusions. Ethical spectacle reminds the viewer that the spectacle is never reality, but always a spectacle. In this way, ironically, spectacle becomes real.

REAL SPECTACLE
For spectacle to be ethical it must not only reveal itself as what it is but also have as its foundation something real. At this point it is worth reiterating my initial argument that to embrace spectacle does not mean a radical rejection of the empirical real and the verifiably true. It is merely acknowledging that the real and the true are not self-evident: they need to be told and sold. The goal of the ethical spectacle is not to replace the real with the spectacle, but to reveal and amplify the real *through* the spectacle. Think of this as an inversion of Secretary of State Colin Powell's infamous case to the United Nations for war in Iraq. Armed with reasoned reports and documentary photos of Saddam Hussein's nuclear ambitions, Powell employed the tools of fact to make the case for the full-blown fantasy of Iraq's possession of weapons of mass destruction. Ethical spectacle employs the opposite strategy: the tools of

spectacle as a way to mobilize support for the facts. As such, an ethical spectacle must start with reality.

An ethical spectacle must address the real dreams and desires of people – not the dreams and desires that progressives think they should, could, or "if they knew what was good for them" would have, but the ones people actually do have, no matter how trivial, politically incorrect, or even impossible they seem. How we address these dreams and desires is a political decision, but we must acknowledge and respond to them if we want people to identify with our politics. To engage the real as part of an ethical spectacle is not the same thing as being limited by the current confines of reality. For reality is not the end but a point of beginning – a firm foundation on which to build the possible, or to stand upon while dreaming the impossible.

DREAM SPECTACLE

The poet Eduardo Galeano writes of utopia:

> *She's on the horizon… I go two steps, she moves two steps away. I walk ten steps and the horizon runs ten steps ahead. No matter how much I walk, I'll never reach her. What good is utopia? That's what: it's good for walking.*

This is the goal of the ethical spectacle as well. The error is to see the spectacle as the new world. This is what both fascist and commercial spectacle does, and in this way the spectacle becomes a replacement for dreaming. Ethical spectacle offers up a different formulation. Instead of a dream's replacement, the ethical spectacle is a dream put on display. It is a dream that we can watch, think about, act within, try on for size, yet necessarily never realize. The ethical spectacle is a means, like the dreams it performs, to imagine new ends. As such, the ethical spectacle has the possibility of creating an

outside – as an illusion. This is not the delusion of believing that you have created an outside, but an illusion that gives direction and motivation that might just get you there.

I would love to give an example of the ideal ethical spectacle, one which incorporates all the properties listed above. I can't. There isn't one. The ideal ethical spectacle is like a dream itself: something to work, and walk, toward. Progressives have a lot of walking to do. We need to do this with our feet on the ground, with a clear understanding of the real (and imaginary) terrain of the country. But we also need to dream, for without dreams we won't know where we are walking to.

Progressive dreams, to have any real political impact, need to become popular dreams. This will only happen if they resonate with the dreams that people already have – like those expressed in commercial culture today, and even those manifested through fascism in the past. But for progressive dreams to stand a chance of becoming popular, they, too, need to be displayed. Our dreams do little good locked inside our heads and sequestered within our small circles; they need to be heard and seen, articulated and performed – yelled from the mountaintop. This is the job of spectacle. Spectacle is already part of our political and economic life; the important question is whose ethics does it embody and whose dreams does it express.

Politics in an Age of Fantasy is an extract from *Dream: Re-imagining Progressive Politics in an Age of Fantasy* published by The New Press, 2007. This extract was originally published on Turbulence.
www.turbulence.org.uk
www.dreampolitik.org
www.thenewpress.com

Seven Live Art Tips

John Jordan

When I was a younger artist – say 20 years or so ago – what did I need to hear? I'm not going to talk about my practice, instead, I thought I would propose seven tips – seven tips on Live Art.

1. Live Art

As far as I'm concerned, the concept of art is a very western concept. That there is this thing – art – that is separate from life is a recent idea. Most people in the world don't have a concept of art as something distinct from their everyday life. It is a bit of a cliché but in Bali they say: "we don't really have a word for art, we just do everything in the best possible way we can." For me that's a pretty good way of defining my practice. Art is simply doing and doing it *well* – with attention, with crafting and with creativity. So the first thing I would say is – do not ever, ever worry about whether the thing you are doing is art or not. Just do it well, do it beautifully, put a lot of time into it and don't try and squeeze it into that tiny box called art. For me, the most important thing is to apply your creativity and your imagination to life. Upset the canons – dissolve and expand the definitions of what art could and should be and just do what you do.

2. I

Well, whether you are in the box or not in the box that they call 'art' they will try and put you in one. They will try and define your practice – they will try and say *she* is the one who takes all her clothes off or *he* is the one who works with homeless people. And the other thing they will try and do is to try and flatter your ego, will promise you fame and perhaps even fortune. They will promise you – a solo show, a mono graph, a retrospective, and so on. In a society of deep pathological individualism – a society where we have replaced religion with celebrity culture, the society of the I-pod and the I-movie, a society riddled with the illusion that the 'I' is a separate thing from the world – it's very difficult to resist the art world saying: "come on you're a gifted 'you', you are a special 'I'." But none of us are this island of 'I', separate from society and the more we forget that illusion the less isolated and lonely we will become in our practices.

We are artists not brands. It is easy to fall and slip into that space where we become a brand, where what is more important is your name and your fame. The artist "I" becomes more important than your practice, your work and your passion. So let go of it, let go of the name trap and concentrate on the work process, concentrate on connections and relationships, on collaborating and, as Lois Weaver says, on "creating your community" and doing what you do best.

3. Courage

I am kind of obsessed at looking at the roots of words because it often tells one what words are really about. The etymology of the word 'courage' is from the French and it comes from *coeur*, meaning heart. So at the root of courage is the notion of the heart – of following your heart.

The most beautiful thing about being an artist is that we actually have the courage to make our dreams actions. That we have the courage to have an idea, to start with a little drawing in a notebook, or an idea in the bath and turn it into a thing that exists in the real world. That's a very courageous thing to do and don't ever, ever, let anyone tell you that what you're doing is not realistic, don't ever let them say its too ambitious, don't ever let them tell you that it is not possible. Because when you do what you do best you will soon start to see that you begin to unravel something weird in the universe. That might sound really hippy, but I've had the experience (which I think many of us have had) that when you focus on a project suddenly things start to fall into place as if by magic. Perhaps an email arrives saying "I have a really old bus that I have to get rid of, do you know anyone who needs a bus?" And your project needed a bus! Or you are in the library and a book suddenly falls into your hands and it is exactly

the book that you need to read for the project. It happens to all of us and fundamentally it's about courage. It's about following our heart and not being diverted from that path. It's also about the courage to tell the truth and not worry that they might kick you out of that little box.

I was giving a talk at Tate Modern the other week. (It was a really shit thing. Lois Keidan was there. It was really shit, not because Lois was there, but mostly it was). Most of my practice is merging art and activism and I was put on a panel with a women that runs the website for Tate Modern. The two of us opened the whole session, titled *Art Globalisation and Life Style*. Yuck. I spoke about the Clandestine Insurgence Rebel Clown Army, which was a project I set up, involving lots of anarchist clowns and at the end someone in the audience asked the women "would you let the clown army into the Tate Modern?" "Yes of course" she replied "I'd love to have the clown army here – although its not my decision to make but we would love to have you in the Tate Modern … it would be wonderful … I'm sure that will happen one day." "That's great" I said (just before she had mentioned that forty percent of the Tate Modern's funding was corporate but that this did not have any effect on their programming). "Wow, that's great, we could come and do a piece that looked at the role of the Unilever Corporation" (you know Unilever funds the massive Turbine Hall commissions). "We could do something about how Unilever tried to pressurise the European Union to keep trading with Burma during the dictatorship, because the European Union were proposing boycotting trade with the Burmese dictatorship. So we could do a piece celebrating how Unilever tried to stop that boycott on trade, so that they could continue doing business with a

dictatorship." Unsurprisingly she responded by saying "well we couldn't let you do *that* exactly".

But it was about a certain courage, the courage to not care if I am not invited back to Tate. Sometimes I call it the "bank robbers' attitude." Bank robbers never rob the same bank twice so you should treat institutions the same way. Go to institutions and you do what you wanna do in the best way you can do it, and don't care if you're not invited back, because its more important to do what you do, in the best way that you can do it, than it is to be invited back.

A commercial break.
This is a commercial break brought to us by a young artist who is really inspirational for me. He is only half my age but we work together really well – here it is – the commercial break …

(*The Vacuum Cleaner's* Prayers to Products *can be viewed at http://tinyurl.com/4wyxg3.*)

The video we have just seen is an exert from a dvd we put together of art activist practices called *Thirteen Experiments of Hope*. You can buy the dvd online from Unbound – www.thisisUnbound.co.uk – and it only costs a fiver.

That's the end of the commercial break.

4. Money
We live in a society that prioritises money before life and pretty much everything else on the planet. And it's pretty hard to live without it, but the thing I would say is try and live with the least amount of money possible.

If you really need something borrow it, make it or steal it and try to free your time from wage slavery. The less money you need, the less wage slavery you need to do, and the more time you have to do what you really want to do in the best possible way you want to do it.

And what about dependence on arts funding? Well, it's the bank robber technique again. You go to the institutions and get the money that you need to do what you want to do, but don't worry about not getting funding the next time, don't self censor yourself in fear that you will lose funding. If they refuse to fund you, be creative – you could set up another company with a different name, you could go to political exile – lots of options, but whatever happens don't let your creativity be dependant on funding.

So many radical performance groups start off small doing what they want to do. Then they get funding and its wonderful for them because they have to do a bit less wage slavery. Then they get an administrator and maybe even a building and before long they spend their time filling in forms and not being creative and soon they become completely dependant on funding. The funding has enabled them to grow but now they have become too big to be self reliant and so the work becomes less radical so as to keep funding coming in. The system wants us to be completely dependant on it rather than free to do it ourselves (after all it's the strategy of all colonialism) and we have all talked about doing it yourself which I think is the next tip.

5. Do it yourself
Other panellists in this event, such as Marisa Carnesky, talked about this and so did Lois Weaver and I think even Gary Stevens, so I don't need to say much apart from: don't wait for commissioners, or galleries and festivals to fund you or put you on – do it yourselves,. Set your own things up. It's a

beautiful experience setting your own structures up, you get to meet new people and you get an incredible sense of empowerment to do your own stuff without having to depend on others. The dvd I showed came out of this – a completely DIY ethos. We set up a thing called the Laboratory of Insurrectory Imagination, we raised a hundred quid, we used a squatted social centre (RamARTS), and a hundred artists and activists from around the world came. We organised a potlatch meal – where everyone brings a dish to share and every morning for breakfast we were treated to a huge DIY buffet – and we ran workshops and went out and did five actions a day for four consecutive days. Creative actions in the streets – it was fantastic. All it cost was a hundred quid and involved a few emails for publicity and we were totally free to do what we wanted to do. We were followed by about forty cops most of the time but apart from that we were fairly free!

6. The End of the World

I only have two minutes left! 'The End of the World' in two minutes!

We live in really interesting times and I wish I could say to you that the future is going to be really bright and easy and you're all going to have really grand art careers and get loads of funding and be really famous and manage to keep your passions intact. But there are a few problems. I'm going to try to explain the problems quickly in a graph (*draws a graph which finishes with a sharp upturn*). This one is called Climate Change – or more precisely Climate Chaos and we are about *here* in time (marks the graph near the start of the upturn) and *this* (*marks the graph near the top of the upturn*) is the point of rapid collapse of global ecosystems. The distance from the first point to the second is about ten years. We have

about ten years to turn our CO_2 emissions and climate change around – even the European Union say this and they are not known for their radical environmentalism. If we go above the two degree tipping point of global warming, then we hit a terrifying series of uncontrollable feedbacks – known as 'run away' climate change. The whole climate system will tip into chaos, it will start to behave in ways we can't imagine. We are already committed to 1.3 degrees above normal warming – even if we stopped every car, plane, factory today – which means we have 0.7 degrees to play with, it's not a lot.

The other thing that we are going to have to do deal with in the next ten years is described in this graph representing Peak Oil – the process of energy resource depletion (*draws a graph in the shape of a bell-curve*). We are about to hit *this* moment (*marks a point at the peak of the graph*) where the world's economy shifts from one based on demand dictating supply to one where the rapidly depleting oil supply will dictate the demand. And yet the demand will continue to grow! When this happens the economy is likely to collapse, more wars for energy will erupt, there will be more chaos everywhere ...

I wish I could say to you the future is going to be bright. It's not. The end of the world is going to happen ... in your life time. And I can guarantee that. But there are two kind of ends of the world: there is either the end of the world as we know it in terms of capitalism, consumption, ecological devastation, of individualism, of competition, and of growing inequalities OR there is the end of this world as represented by this graph.

I know which one I prefer. I also know that artists are very good at changing the path the world takes. Don't ever let anyone tell you that art can't change the world because it can and it always has.

(If you want to talk to me afterwards I can give you a few tips on how to do that). What it involves, however, is artists having the courage to leave the constraints of the art world, to leave the isolated ego of the art world, and apply their creativity to changing the world together with others. And it doesn't matter if changing our world is called art, it doesn't matter if it's called activism – we just have to take the risk and then maybe we will see the world end in the way we would choose it to end.

7.

> *"Apocalypse is always easier to imagine than the strange and circuitous routes to what actually comes next."* Rebecca Solnit: *Hope in the Dark.*

Seven Live Art Tips is a transcription of a presentation for *Everything You Wanted to Know About Live Art But Were Afraid To Ask*, May 2007. *Everything ...* is a collaboration between the Live Art Development Agency, Queen Mary University of London, and East End Collaborations. www.thisisLiveArt.co.uk

Bite-sized Chunks from my Life

Rajni Shah

Why are we angry? We are angry because we have been mistreated, we are angry because no-one understands, we are angry because everyone understands and yet no-one acts, we are angry because no-one really acts, we are angry because our thinking is not aligned with the world, we are angry because the world is not aligned with our thinking, we are angry because we see injustice, we are angry because we have no equivalent to the African-American movement, we are angry because we are white, because we are women, because we have choice, because we are men, because we have power and we have no power, because we have power and we don't acknowledge it, because we have boxes and the ability to shape them from the inside, because there is every need for a social justice movement and yet it is so hard to justify. We are angry and we're not sure why. These issues are complicated.[1]

Diversity is a rather huge subject area. Its definitions bleed into every corner of our work and of my life. I have found it baffling, overwhelming to write intelligently on this subject. What I offer here are bite-size experiences that in some way make up my life, my opinions. Perhaps I offer them because

they are easily digestible, perhaps because I want you to read between my arguments. The essays are both image and language-based, as were the experiences. They all begin here:

1. Initiation into the world of brownies

In May 2003 artists from all over England performed at the decibel[2] x.trax performing arts showcase. It was one of the first big decibel events. Black, brown, yellow, artists of all colours came together to perform in one place, to showcase their talents to international promoters. And if you were white, just this once, you didn't stand a chance. Everyone applauded. This was to be celebrated. Finally, a voice for the disenfranchised, a chance to address inequality of programming. Everyone traipsed around Manchester dutifully watching a rather random mix of work for four days. Following the showcase, some artists were programmed into new spaces. The event was declared a resounding success. And in some ways it was. But there was something deeply unsettling about the experience for me, something that made alarm bells ring inside

me. And more disturbingly, it was something that didn't seem to ring alarm bells for many of the other delegates. This safe, superficial exploration of issues of racism, elitism and accessibility was perfect because everyone could applaud it without fundamentally changing anything. I felt alienated.

This was when I became intensely aware of the colour of my skin, when I started to feel like I was living in a truly segregated arts community, when I suddenly felt at risk of being labelled 'Asian' rather than 'artist' or 'producer' or 'director'. This was also when I realised I could own a part of this debate as much as anyone else. And for the first time in my life, I wanted to be around other 'brownies', I desperately wanted to join forces with other artists who might be experiencing the same thing.

2. the body as culturally diverse artefact[3]

How are we framed (and how do we frame each other) as brownies? How am I already framed in certain situations as a black man / Asian woman etc? Is art representative of the fact that blacks, whites and brownies all use each other's games, music, language, walk? Do I have a responsibility to be a role model to younger brownies? Should I take advantage of initiatives like decibel that label me as an artist of colour?

the body as culturally diverse artefact opened up questions. At the end of the project, we hosted an open sharing with performance, text, video and an opportunity for interaction. We asked viewers that they start to recognise the complex structures, the individualities that lie beneath a blanket statement like 'cultural diversity'.

In asking questions, discussions began, topics were raised, and it seemed that an atmosphere of openness was created, where people felt able to challenge and be challenged; not without bounds, there was still 'polite conversation', but perhaps less of it than is usually present at such events. Yes, attendees were inclined to say well done and thank you but also, I think, to be disgusted or disquieted, and some, to ignore the topics in question all together, by talking about washing machines, catching up with friends, resorting to old patterns, safe areas, but not without some awareness that this was what they were doing ... (Extract from evaluation for *the body as culturally diverse artefact*).

In many ways, the week of research was frustrating. All four participants were seeking answers, but I think we were asking different questions. On the last day, before the public sharing, we sat down in the space and just talked, argued; we talked about what our childhoods had been like, the choices our parents had made, the choices we had made, our frustrations and ambitions as artists. One thing we agreed on was that we did not like the way we were being treated by funding bodies which had created a 'culturally diverse sector' safely separate from the mainstream. However, on most other issues, we disagreed. We disagreed about how we wanted to be seen, about what responsibilities we had stemming from our parents' choices, about whether it was possible to have 'no sense of nationality'. I think it's safe to say that we all came away having raised many more questions. If I came away with any answer, it was an answer to the question: "What's really dividing the arts sector?" And the obvious yet often wilfully ignored answer: class.

3. Writing

"It turns out that the white boys on the train are American. My Theron is American. But for me, he is primarily Theron. This is also how I define myself, primarily Rajni. And I have always been allowed to define myself this way. And yet the privilege of being an

individual seems to be tied very closely with class. If you are a middle-class or upper-class individual, you will probably continue being an individual. If you are a lower-class individual, you will struggle not to be labelled a trouble-maker. I am on the border between being a troublemaker and an individual. But my conviction that it was worth continuing the struggle, on the borders, not immediately getting anywhere, that (surely?) came from my middle-class status ..." (Extract from Rajni Shah, diary 2005).

4. Mr Quiver[1]

So tell us a bit about yourself to start with, what's your name, where are you from, how old are you?

My name is Rajni Shah, um, I'm from London and I'm 27 years old.

Okay. Now I understand that you have a fairly interesting history in that you've lived in a number of different countries. Can you tell us a little bit about your family background? You know, who is your mum, for example? Is she from London as well?

Okay, um, I feel a little strange telling you about my family actually, but, well, my mum's British, like me, um, she and my father were both born in India. Um... I grew up in Switzerland, and then later on lived most of my life um near Oxford. I, I ... I studied in Cambridge and then went to live in America in the United States for um, about three years, and -and now I'm based in London, um that's-

Okay, that's great. (Extract from soundtrack for *Mr Quiver* by Rajni Shah).

I developed the solo show *Mr Quiver* over two years. As well as being an intensely personal process, it enabled me to find new ways of communicating a lot of complex thinking around issues of race, belonging and nationalism. The show is now an installation performance lasting four hours, during which the costume, patterns of maps in salt, lighting and sound are repeatedly created and destroyed. I perform alongside Lucille Acevedo-Jones (costume designer) and Cis O'boyle (lighting designer), slipping in and out of performance, repeatedly inhabiting costumes of Elizabeth I and an Indian bride, while Lucille and Cis repair and re-hang costumes, layer music, swing, rig and de-rig lights, and draw and destroy the salt maps. Our three patterns of improvised (non)performance coincide and diverge throughout the four hours, slowly breaking down as the audience walks between and around us, enters and leaves

I've often wondered whether it is thanks to the work of initiatives like decibel that I ever made *Mr Quiver*. I find it an exciting and topical piece of work, born at least in part from my anger over the way coloured artists are being treated in this country. It's a response to the boxes, to the many attempts to make one genre out of 'Asian art' or 'black art'; it's a plea for individualism but also recognises that we cannot escape being identified by the way in which others see and categorise us. Most importantly, it asks these questions equally of each audience member, it's a reminder that we all have a past, that we all suffer or succeed by the assumptions others place on us, and that we're all equally implicated in this debate whether we like it or not.

5. Traditional forms

At the recent *Pride of Place* festival[5] in Woodbridge, Suffolk, I was asked to lead a session on cultural diversity. We had an enjoyable and engaging debate, munching on London-bought Indian sweets as we went. Afterwards, a member of the local council approached me: "I'm not sure I agree with what you were all saying about finding new languages by merging traditions. Surely there is a great amount of worth in retaining traditional artforms and values?"

The Live Art Almanac

he said. I replied that yes, there was. And I genuinely agree that there is a great amount of worth in sustaining traditional art from all over the world. The problem at the moment, as I see it, is that the art itself is getting ignored in favour of the colour of the artist's skin. So there is very little specific attention being paid to this issue – artists working to preserve traditional forms are given the same parameters as artists whose work has nothing to do with those traditions. Categorisation is not based on social background (giving priority to artists who have not previously had opportunity) or talent but solely on skin-colour. In my opinion this won't bring about the preservation of traditional forms or encourage innovation, much less do anything to tackle social injustice; it will simply alienate artists from one another. What's more, I believe that this kind of segregation actually reinforces hierarchy as these 'culturally diverse' platforms become less and less critically engaging and encourage funders, promoters and programmers to lump non-white artists into one indiscriminate category rather than recognising and nurturing them as independent artists.

6. An Invitation to Tea[6]

We're sick of cultural diversity. We don't know what it means, why it matters, sometimes we're not even sure if it's a good thing or not. Can this really be the way forward? We think that there are still issues to be addressed, and new ways to address them. So we want to create an atmosphere where you can have useful, truthful conversations, where you can express any opinion and have it heard. We want you to meet other artists, arts managers, producers and policy makers from the region, to share experiences and exchange ideas about the future. We're inviting you to share our tea, our food, and our time. We really hope you can make it.

Why is there so much focus on culturally diverse art in the south east when 95% of the population is white?

Positive action: does it work? Is it helping to move things forward or widening divides and encouraging segregation?

How can the arts help to develop racial and cultural understanding in our current climate?

Is there an audience for diverse work in the South East? Are 'cultural diversity' initiatives in rural areas a farce?

Is it enough to programme non-white artists, regardless of the kind of work they are making? Or do we need to go deeper to effect real change?

Does the term of 'culturally diverse arts' stereotype artists? (Extract from Saj Fareed, Tracey Low and Rajni Shah, *An Invitation to Tea* conference)

An Invitation to Tea took place at the Farnham Maltings in Surrey and offered delegates from across the South East region an opportunity to share experiences of cultural diversity with other artists, arts managers, producers and policy makers from the region. The conference was organised by Saj Fareed, Tracey Low and myself, at the time all senior management fellows funded by Arts Council England, South East. The idea was to provoke debate by presenting the issues in unusual ways (e.g. tea parties, a pub quiz). It aimed to open up the complexity of these issues rather than offer a nicely packaged, easily digestible solution.

It was always going to be a challenge inviting a mixed group of delegates from the South East of England to come and talk about cultural diversity. This is a region where, famously, approximately 95% of the population is white. Many people feel pressure from funders to become more diverse, without an understanding of how or even why that might happen within their organisation. We wanted all opinions at the conference to have equal validity,

and for people to feel free to make criticism without fear of judgement, so we played with format, making some unusual decisions about how the day was structured, including long discussion sessions and a two-hour lunch hosted by performance artists.

Some people loved the conference, some people hated it. On reflection, the thing that I am most proud of is that it had the potential to fail. It's not often that you come across a cultural diversity initiative that is prepared to take that risk, which is why we end up with so many 'multi-cultural celebratory' events, even at the higher level of culturally diverse programming. But we recognised that these were difficult questions in a difficult region, and we didn't want to pretend they weren't. The delegates who were least happy with the day were mostly frustrated at the lack of resolution. And we could have offered more resolution in the structure. But the day made people think differently, made new introductions, and if it made some new frustrations, perhaps, in some ways, it achieved its aims.

7. The conversation continues
And finally, a small post-script. On sending a draft of this article to the editor of *engage* journal, Karen Raney, she asked me some further questions. Instead of working the answers into the body of the article I thought it might be more enlightening to post both questions and answers in their raw form, to bring the article to the present day.

KR: I wasn't sure if you see the segregation and alienation you describe as a necessary stage, or as avoidable. If it's avoidable – how? The same with 'ignoring the art'. Is this a necessary stage, or avoidable? Organisers of initiatives like decibel feel they correct an imbalance by channelling funds in a

different direction than usual. They have asked people what they want and tried to provide it – such as open-ended funding, not tied to a particular project, and trying to be specific to each art form and what it needs. Do you think it's unhelpful even to have funding streams earmarked for artists from particular backgrounds? Or do you think they need to be managed differently?

RS: Karen- this is complex and I'll try to answer succinctly! I think that at the heart of your question is a request that I unpick further my criticism of initiatives such as decibel. On the one hand, decibel did what it set out to do and raised the volume of debate around cultural diversity in the arts. What it did not do (and perhaps this was never its aim) was to raise the level of that debate. So we're stuck now with a very loud, very crude definition of what it means to be culturally diverse within the arts sector. Of course, from my perspective, I think things should be done differently (and that's why I've chosen to respond with projects like *An Invitation to Tea*). I think that initiatives should be aimed at integrating different artforms and artists, at shaking things up, juxtaposing unlikely work, challenging promoters. Instead, many promoters get away with hiding 'difficult' work within programmes like Black History Month. So we've got a long way to go before artists of colour are actually recognised as individual artists, working professionally in a number of very different ways that require very different types of support. Many artists whom I believe are making serious, exciting, and often political work either feel that their work is getting ignored or that they are being forced to make work with a particular ethnic focus just because that's where the money is. There have been very few opportunities where artists of colour feel they are able to make the work that they

want to make and present it in the way they want to present it. Therefore initiatives like decibel can feel rather out of touch with the real needs of many professional artists.

So that's my take on (a small part of) it. But I should acknowledge that I'm speaking with the advantage of hindsight, and also as someone who is particularly interested in raising difficult questions and in art for social justice. There's no easy solution to the many issues raised by a blanket term like 'cultural diversity' and there are countless agencies, organisations and individuals across the UK who have been effecting change and challenging opinions in many different ways. This article represents my opinion. Ask ten other artists and you'll find ten more.

6. *An Invitation to Tea* took place on January 20 2006 at the Farnham Maltings. Artists involved were Ansuman Biswas, Dreadlockalien, Silke Mansholt, Lucy Panesar, Qasim Riza Shaheen, Yara El-Sherbini. For further information visit www.artscouncil.org.uk/aninvitationtotea.

Notes

1. Opening text by Rajni Shah
2. Decibel is a funding initiative that forms part of the diversity strategy of Arts Council England. Decibel is a cross-arts programme designed to support black, Asian and Caribbean artists
3. *the body as culturally diverse artefact*, April 2004 as part of the Chisenhale Dance Space Artists' Programme. Artists involved were Sam Lim, Persis Jade Maravala, Colin Poole and Rajni Shah.
4. *Mr Quiver* has toured nationally including being performed at the National Review of Live Art 2006.
5. 'Pride of Place' is a consortium of regional touring theatre companies taking a lead in the debate about the relationship between place and art and the ways in which rural communities contribute to contemporary Britain. See www.prideofplace.org.uk for further information.

Bite-sized Chunks from my Life was commissioned for *engage journal* and was first published in *engage journal 19: Diversity*, 2006.
www.rajnishah.com
www.engage.org

Live Art UK: Keynote Presentation

John Wyver

On Sunday 13 December 1998 – not yet nine years ago – at 10.30 in the evening BBC2 screened Richard Billingham's 50-minute film *Fishtank*. This is an eccentric and allusive film composed from the artist's close-up camcorder footage of his mother, father and brother living in a Midlands council flat. As the *Radio Times* billing had it, "Ray stands alone in the dark kitchen, feeding fish. Liz plays computer games. Jason swats a fly." There is next-to-no story, the images are often both obscure and disturbing, and the soundtrack largely incomprehensible, but the whole is a totally original film that rethinks what social documentary can be at the same time as depicting an absurd, violent and yet loving claustrophobic world of which Samuel Beckett might have been proud. The film was a co-production between my company Illuminations and Artangel, it was assembled with genius editor Dai Vaughan and benefited hugely from the input of Adam Curtis and James Lingwood.

Fishtank was part of *Tx.*, a BBC2 strand that Illuminations produced and coordinated and that also included new work from Michael Clark and

Wendy Houstoun, Nick Waplington and John Maybury. The series aimed to present contemporary art and contemporary takes on the past largely in their own terms, with minimal conventional mediation – and we won a BAFTA and other awards for our pains. But it now seems to me utterly extraordinary, truly inconceivable that *Fishtank* was broadcast, let alone on a mainstream channel during more-or-less peaktime.

Before exploring why there are no such broadcasts today, let me reflect for a moment on the fact that, apparently, *Fishtank* had an audience of some 700,000 viewers. Which is pretty good in the terms of contemporary arts but entirely negligible for televsion. I have to acknowledge, however, that Illuminations made Channel 4's lowest-rated primetime programme of 2005 (that year's Turner Prize broadcast) and earlier, also during *Tx.*, we were responsible for one of the three lowest-rated primetime broadcast programmes ever, or at least since the start of accurate measurements (according to a analysis by the trade magazine *Broadcast*): our film made by Deborah Warner of Fiona Shaw

performing *The Waste Land*. Needless to say this is one of the two or three productions that I'm most proud of having had an involvement with.

So *Turner Prize 2005* achieved an audience of less than 200,000, *The Waste Land* less than 100,000 and *Fishtank* the more respectable 700,000. And what did we know about those audiences and the people who composed them, beyond their aggregated total? Zip. Nada. Absolutely nothing. Just occasionally someone will send an e-mail or mention over a drink that they appreciated or were provoked by something we made and got shown a decade or more ago. But that's the closest, during the broadcast era, that most makers came, and often still come, to their audience.

Nor did we work to develop a broadcast audience, beyond seeking press previews. We provided nothing in the way of context, no framework, no interpretation. What seemed important was simply and straightforwardly the creation and dissemination of the work. The broadcast audience, in greater or lesser numbers, was, simply, there. No longer.

Fast forward nine years, with a capsule history of what's happened to television in Britain and elsewhere. Rapid rise in the number of channels: Sky, cable, digital, broadband. Rapid development too of competing media for our attention: games, dvds, the Web, mobiles. On or around 1 January 2000 the broadcasters – the BBC, ITV, Channel 4, Five – noticed this because, crudely, their share of viewing, especially in households with Sky, was falling off a cliff. Their response was a retreat to the middle ground of mainstream programming focussed on audience (or rather ratings) maximisation. Hence reality television, *Big Brother*, formats, and property shows. Hence too the curtailment of oddball slots like that occupied by *Tx*.

and the refinement of each channel's proposition to a single, immediately graspable proposition. Low-rating, ambiguous and (for commissioners at least) perplexing arts programmes are, with a few exceptions like Channel 4's continuing commitment to contemporary opera films, among the first casualties. (Why, I remember a senior Channel 4 figure, now the head of an Oxford college, asking me, quite without irony, why would you set out to make something mysterious for an audience?)

Given this, and given that as producers we lived in and off an economy that for a time had rather more enlightened ideas, are we down-hearted? Well, I regret that it's no longer conceivable to propose to broadcasters ambitious work like *Fishtank* and expect any other response than a dismissive sneer. And as a viewer I profoundly regret that I see little on television to challenge or provoke or even, in a positive way, puzzle me.

But of course other things have been going on which suggest new ways of working with arts media, new production methods, new forms of distribution and new audiences. The cost of production equipment – excellent cameras, desk-top editing systems, graphics and so forth, has fallen significantly, and at the top of the range, with HD, continues to fall. Potential distribution channels have multiplied exponentially: digital channels, dvds, online, media in education and museums, mobiles and the rest. And with each channel has come at least the possibility of new audiences – and just as important the possibility of new ways of working with, talking to, understanding and responding to those audiences.

So one of the initiatives that we've developed, entirely with our own resources, is a series of half-hour profiles of contemporary artists, mostly visual artists, called theEYE. We've made 41 of these films

so far, with figures including Anish Kapoor, Tracey Emin and Grayson Perry as well as with older, less fashionable figures like Liliane Lijn, Sandra Blow and the late Karl Weschke. We distribute these on dvd, sell them occasionally to television, licence them to education, see them widely used as context for exhibitions and, soon, they'll be available for streaming and for pay-per-view download. We formulated theEYE in part because of producer push: we *wanted* to make the these films; but also because of audience pull; teachers, collectors, students, galleries, interested exhibition visitors, artists themselves *wanted* films like these, and as television (and the Arts Council) withdrew from providing them, there was an opportunity for us to fulfil this audience demand. We don't make a fortune from the series, and they're done very much as collaborative partnerships with the artists, but – precisely because television no longer produces such films – these are collectively the best account on film of the visual arts in Britain over the past five years.

And we know, unlike when we made television programmes, that they are appreciated and used by disparate audiences. We get extensive feedback and, mostly, enthusiasm and we can see very directly who is buying them, how they are being employed and in what contexts they are reaching admittedly often very small audiences at any one time, but audiences who appear to be responsive to the particular qualities that the films offer.

I said we've done this entirely on our own, within broadly a commercial framework, investing a lot of time and energy, together with modest amounts of cash, and seeing that returned over the long term. My frustration is that there's absolutely no public support for documentary work of this kind: not from Arts Council England, which stopped funding documentaries in 1999, not from the Film Council, and certainly not from the broadcasters.

Which is one of, but really only one of, the reasons why despite occasional discussions with Lois Keidan and others, and despite elements of documentation by us over the years, we haven't (yet) developed a Live Art version of theEYE. But perhaps that's a discussion that could start again later.

Now, there are some very interesting things starting to happen in broadcasting and media funding, with potentially profound implications for us as both producers and as audiences. Just as there are, most obviously, fundamental changes happening at a dizzying speed in media. In shorthand terms, today we're in a world of Web 2 point zero, of non-linearity, of participation and porosity, of the renaissance of the amateur, of user-generated content and social networking and Facebook and Bebo and Myspace and Youtube and Second Life and Flickr and Last.fm and Broadcaster.com.

At an Arts Council England-organised event recently a succession of speakers led by the esteemed new media producer Anthony Lilley told us about this brave new world, and especially about how we needed to make a profound adjustment in our relationship to the people formerly known as the audience. For Anthony and many others, (and this is to collapse complex arguments) the power of networks changes all the rules, so that participation becomes fundamental to all activity, including the cultural.

Well, up to a point. Paradoxically I feel that in the same ten years that has witnessed the move away from arts broadcasting, I've shifted from a position of leading-edge evangelist for networked media (I made a programme called *MeTV: The Future*

of Television in 1993 for BBC2 which I continue to claim contains the first use of the word "internet" on British television) to a place that's more conservative, more sceptical, a little niche for those who have experienced to a degree a certain disenchantment with the digital.

At the same time that we were doing a lot of work with, for example, online 3D social spaces and inhabited television, I was also producing long-form performance based drama for television: a *Richard II* with Deborah Warner and Fiona Shaw, for example, a *Macbeth* with Tony Sher and Harriet Walter and the RSC, and a version by Phyllida Lloyd of Britten's *Gloriana*. And nothing, then or now, in the digital world, not playing Halo with my sons and kids on the other side of the world, or leading a raiding party in World of Warcraft or setting up my Facebook page or enjoying the Harry Potter puppets on Youtube, or indeed looking at and becoming involved in a LOT of online art, nothing has given me the aesthetic satisfactions and pleasures and provocations, both as a producer and as a member of an audience, that doing those dramas for the screen gave me and still give me. (My examples are from classical drama, as that's mostly what we've done, but the point extends to other forms of performance.) Again, this is a caricature of a complex set of concerns, but I worry away at the thinness, the superficiality, the absence too often of duration and development, the lack of texture and nuance and indeed materiality and embodiment in too much of the digital world and its relationships. But, again, perhaps something for discussion later.

Two other thoughts to close with. One is to acknowledge the extraordinary opportunities that network media (and I'm trying hard not to use the word "new" here; these are "now" media), that Youtube and podcasts and Myspace and Second Life

offer to us all in extending audiences, in speaking with them, in developing conversations, in building loyalty, in enhancing understanding and providing context, in making audiences partners of different kinds with us. And this is not just about marketing, or if it is it's about entirely new forms of marketing, it's about new relationships and new kinds of exchange and involvement. How many of your groups or artists or venues have Myspace pages for example? How many do podcasts? How many have branded channels on Youtube? Maybe you should.

My second thought tries to return us to the values and production frameworks and aspirations of the linear broadcast work that I started with and to my frustrations of not being able to secure even modest funding to make such work now that broadcast is no longer interested. This week the regulator Ofcom announced the terms of reference of their next review of public service broadcasting (psb). Their earlier review, completed in 2005, resulted in an important document (available from their website) which rethinks how we might understand psb and its values and I think the process across the next 18 months, and then the debate about a new Broadcasting Bill in 2009, will take this much further.

Why this is important is that the funding that now supports without challenge the BBC and Channel 4 will become increasingly contested, and it may well be that new configurations will emerge to determine how extensive cultural monies are spent, how cultural productions are created and how audiences for cultural media are developed. Ofcom's proposed Public Service Publisher (which you should certainly know about) is one part of this equation, but there are other frameworks too and this is going to be a key set of debates – social, cultural and aesthetic debates, debates centrally and

fundamentally about audiences – over the coming months. I know Arts Council England is gearing up to become centrally involved in this, and I think it's important that all of you who are interested in the possibilities of working with media and using media to develop and satisfy and provoke and talk to and challenge audiences, it's important that you become involved too.

Live Art UK: Keynote Presentation was originally presented at the Live Art UK Networking Event, September 2007. John Wyver is a writer and producer with Illuminations. www.liveartuk.org
www.illuminationsmedia.co.uk

Travels Through *1001 nights cast*

Barbara Campbell

Edit of script for performance # 17 of *1001 nights cast*

Performed at 9:56PM on 7 July 2005 from Paris

Alone in Paris, she was without guidance. No one here could assure her of a risk-free path. She was out of her own country and found it difficult to make decisions. But today the problem had to be confronted. How to go about it? She was too shy to stop a woman in the street and have to struggle with the language: so hard to convey the precise meaning, especially when it came to the important matter of where to get a good haircut.

She perceived from the number of well-groomed men in the area that here, in this small section of the city, perhaps more than any other, appearances mattered. She walked the narrow streets, peering into shop-fronts, looking for the right constellation of visual cues. She passed by several salons, which may have been acceptable but for that ominous beast in the corner: the retro hairdryer helmet on wheels.

She came across a tattoo parlour. Surely if you were in the business of body adornment, she

thought, you would know about the masters and mistresses of hair in your immediate environment. It was a shame the woman at the counter spoke such little English. From the recesses of her own unreliable vocabulary, she found all that was required under "c": chercher, les cheveux, couper, cette arrondissement. It wasn't really a recommendation but the young woman pointed further up the street, towards the Beaubourg.

She scanned the shop through the plate glass. No blow dryers on wheels, only men: men in the chairs, men wielding scissors, men talking to other men via mirrors, one man sweeping, another one shampooing, and right in the front a sweet looking, slightly-built Asian man at the counter. One last sign clinched it for her and that was the sign on the window itself. Just one word – an invitation to engage in life itself: "Sing".

He assured her he could fit her in that very afternoon. Nor was he fazed by her already short hair. There was just one thing: she wouldn't permit him to use the electric clippers – as short as possible but by hand only. She knew it would be stretching

both time and talent, but the display of manual skill was the thing she enjoyed most about this ritual. Besides, at that time, she needed physical contact, even if it were only at the hands of this stranger.

She knew she made him nervous. She could see her own taut expression in the glass. But it wasn't often she put her trust in the hands of another man, another cutter, that is. When the cut is this short, each hair counts. Round and round he went, checking, cutting, sculpting, thinning, refining.

Gradually her facial muscles relaxed, her breathing became deeper and she started to ask him about himself: she'd seen so very few Asian men in Paris.

It was his shop. He'd been here eight years. He'd been in Paris thirty years. He came with his parents. They escaped from Cambodia. They'd been refugees. The name of the shop was in fact his name. His name was Sing. She would be back.

Edit of script for performance # 66 of *1001 nights cast*
Performed at 8:49PM on 25 August 2005 from Paris
No story has come in and now, with an hour or so to go, something must be conjured from the ether. I discover when I retype my prompt back into Google that back in 2000, *Behind the Curtain* was a project in which bloggers recorded a day in their life. Although that project has ended I think, why not take that very simple idea as a way of manufacturing a script for tonight's performance? For I am the man, well, woman, behind the curtain of this particular project and this is a day in its life.

Since this is a narrative, I'm obliged to start at the beginning of the day.

The alarm clock in my head goes off at 7.30 am, as usual, no matter how much sleep or wakefulness

or nightmares or good creative thoughts have filled it in the preceding eight hours. At this particular 7.30 it's raining and so even harder to swing the feet off the bed and onto the floor, but I do, because the show must go on, it's the contract I've signed with you, my audience. I shuffle over to pick up the old blue pottery mug I use as a water container and on my way to fill it from the bathroom I turn on my PowerBook G4. By the time I've shuffled back with the water, the computer is booted up and my eyes are preparing themselves for reading.

I launch straight into the *International Herald Tribune* link to stories from the Middle East. There's more news from Gaza but for the Western media outlets, it seems like we're coming to the end of that particular episode of the narrative. The Palestinians are happy for now, the evicted settlers unhappy but resigned. So today I turn my attention to Iraq as it struggles to draft a new constitution by a mysteriously contrived deadline. There seem to be big issues still to be ironed out, like federalism and the role of religion in the law and this of course is contrasted with the daily experience of the citizens who must focus on the reality of no water, electricity, security, medical supplies and so on.

I'm struck by one particular quote from a "man on the street" interviewed by the *New York Times* journalist. ' "I am not very convinced about what is going on behind the curtains," Shawkat Falih, 40, a Sunni street vendor in Baghdad said darkly. "The process should be visible and audible to the Iraqi people."' So I choose "behind the curtains" and I wonder if Mr Falih knows that this is also a famous quote from The Wizard of Oz. You'll remember, it comes at the moment when Dorothy and her gang of three finally meet the Wizard. Toto pulls away a curtain to reveal a mere mortal at the controls of the phantasmagoria that is the Wizard – all smoke and

mirrors, *son et lumiere*. So who is the Wizard – the man behind the curtain or the illusion? Plato asked it centuries before in his *Parable of the Cave in The Republic*. I don't suppose any of these illusions or allusions would be playing on the mind of Mr Falih in Baghdad.

I did the watercolour, photoshopped it and posted it onto the site as today's prompt. I also sent it as an attachment to the writer whom I thought might like to respond with a story.

Then followed the usual train of events – shower, breakfast, email writing and reading before I got down to the dreary end of the show: transferring the videos of the performances from tape to hard drive for editing and then back to tape for archiving. So cruel to have to hear one's fumbles in delivery and see the outbreaks of acne. I left it as often as I could to do the slightly more exciting things like cleaning and shopping and making social dates with other artists. Towards five o'clock I started to get a little anxious that no stories had yet come in. I sent off a politely questioning email to the writer whom I thought was going to submit, but by six o'clock, when the writing deadline had passed, there was still nothing.

To complicate matters, I'd organised a little soirée this evening for artists from the Middle East who also have studios here. The first, and luckily only, guests arrived soon after 6pm – Nadjibi, a sculptor and painter from Iran with his young daughter Najarb. It soon became apparent that we had no lingua franca and as usual, it was the child who made the social exchange possible. She showed me some of her own creations and from her pressed clay mask I learnt the Farsi for eyes, nose and mouth. The other little clay face had a moustache like her father's and so that was added to my vocabulary. Of course now, only an hour after

they've left, I don't remember any of these words but she graciously gave me one of the clay masks so perhaps the words will come to me in the night from the distorted clay mouth. With pained apologies from me, I had to explain to my guests that tonight I had no story and would now have to do something about it. A final cocktail of Iranian, French and English words was raised at the door and I turned to face the keyboard.

Now, just before I reach my word limit, I swivel towards the windows and notice the quality of the light. This afternoon's golden glow is what the émigré architect Harry Seidler once called an aberrant light, one that he wanted none of his modernist towers bathed in. I smile as I see Notre Dame à *contre-jour*, the tips of the plane trees just outside glinting and winking in the breeze.

Written for Ctrl+Shift on 29 May 2007 from Madrid
You do have to be careful of Mondays when you're travelling. Everyone has gone back to work but you are left stranded. They won't even open their museums and galleries for you, sometimes not even their shops. And so you wander into anywhere that promises comfort and a way to pass the time. Bookshops, for instance.

And there it was, on the first table of bestsellers: *The Year of Magical Thinking* by Joan Didion. Friends had warned me not to read it at the time of its release: they were afraid I wouldn't be ready for it, that it would open up the wounds again. And they were probably right. But the Monday, the overcast day, the citizens and institutions and booksellers of New York had all conspired to send me a sign and so I bought it. Just around the corner I added grapefruit juice, bananas, olives, cheese and two bialis from the neighbourhood grocery store en route back to the

capacious loft a friend had generously made available for this trip.

Didion's husband of nearly 40 years had died suddenly at home at the end of 2003. The magical thinking of the title refers to her belief that he would be returning and that when he did he would need his shoes and therefore she could not possibly throw them out.

Funny, I thought, how she put these two thoughts together: the fact that he would be returning and the impossibility, the unthinkability that the shoes could be thrown out. Both of these things I encountered in the years after Neil's death but they were separated.

I thought Neil would come back because he did not die at home. He died out in the world. He died near the border of the Australian Capital Territory and New South Wales, Australia, after doing a few errands in the light-industrial Canberra suburb of Fyshwick. He did not return home. His car did not return. And so, refusing the certainty of his death, I had to believe that he was still out doing errands and that he would finish these errands some time. Now, I realise, I thought this way not just because I would never have to accept the truth but because it kept him in a state of usefulness, of engagement with the world he knew and loved. He was running art errands therefore he was productive. I know from certain pieces of evidence – the last "to do" list he wrote, the objects in the car, the receipts in his wallet, what these errands were. I know, for instance, that he went to a glass-cutter to pick up a drinking glass which had had a hole cut into the base so that he could make a new piece in his ongoing Hydromancy series (1993-2002). I know he went to a hardware store to buy a special file which would allow him to recondition the stone of his grinding wheel.

And the clothes. I have heard and read about the practice of disposing of the clothes of the recently departed. Friends and relatives will volunteer to pack everything up almost immediately and 'help you' by taking them off to the local charity shop. The thinking is that it helps you 'move on'. This idea appalled Didion for the reason that her husband would be needing them when he came back. It appalled me because … why? … because all of his clothes were a representation of him. The sheer mass of them could almost be him.

Neil had a limited colour range: blues, greys and blacks. When we first got together, I told him it was possible that he could wear one other colour – to match his blonde eyebrows and set off his blue eyes. We went shopping and for his first birthday in our relationship I bought him a light gold sweater. I was right. He glowed. I'm not sure he thought I was right but he was happy for me to make this change in him and he wore it often. It was the one high-key item in his wardrobe.

For nearly three years after his death I stayed in the studio/residence that we had shared for just over three years. When the time came to physically move on, to a much smaller place, back to my pre-marital city of Sydney, everything that he had acquired in the 18 years of living and working in that place, had to be handled, thought through, packed and distributed in a way that felt right to me. There could be no regrets. It was only in the last week of this operation, which took months of full-time labour, that finally, I could bundle up all those blue, black and grey textiles and take them to the local charity shops of Queanbeyan.

But some items had been distributed long before this point. In the first few days after Neil's death I had given his gold sweater to his brother to wear. Old tee-shirts were used as rags and packing

materials. His leather Blundstone boots were buried in the holes dug for new tree plantings. I had also read somewhere that there is a ritual whereby the coats of a dead man are distributed amongst his friends. And so I dispatched big, soft parcels to men of all shapes and sizes in Victoria, South Australia, Northern New South Wales and locally in Canberra. The last one to go was a full-length grey woollen over-coat that went to our friends' very tall son who was about to step out into the world beyond high school and Canberra and travel solo to Denmark. Ever the champion of re-purposing and recycling, I think Neil would have been pleased with the distribution.

Before leaving the New York loft I selected a book from the shelf to read on the flight and in its place inserted the *The Year of Magical Thinking* for the next reader passing through.

The story written for Ctrl+Shift on 29 May 2007 subsequently appear in a reworked form for night, number 731, 21 June 2007 of *1001 nights cast*.

Travels through 1001 nights cast was originally written for and published in the online journal Ctrl+P Journal of Contemporary Art, Issue 7, July 2007.
www.1001.net.au
www.ctrlp-artjournal.org

Paul Burwell, Experimental Performance Artist

Brian Catling

Paul Dean Burwell, artist and musician: born Ruislip, Middlesex 24 April 1949; (two sons with Sheila Cobbing); died Hull, Yorkshire 4 February 2007.

Paul Burwell was infamous for his exuberant fusions of fine-art installation, percussion and explosive performance. He was a staunch advocate of, and passionate participant in, all forms of experimental art.

In 1983 Burwell, the sculptor Richard Wilson and the performance artist Anne Bean formed an unholy alliance as the Bow Gamelan Ensemble, a multi-media urban-junk-and-pyrotechnics percussion trio. Their first appearance was at the London Musicians' Collective, and for the next eight years the ensemble performed with sublime violence and spectacular anarchy, rattling teeth and window panes in venues all over the world.

"If one had to make a pantheon of Bow Gamelan heroes," Burwell said in 1990, they would include the great engineers Sir Alec Issigonis of the Morris Minor and the Mini, Thomas Telford, Brunel,

and Sopwith of the Camel. Our creed comes from the Balinese: we don't have any art, we do everything as well as we can.

The joy of the forbidden echoed against ritual incantation with improvised fanfares of industrial chaos, always with Burwell's insistent pulse beneath, drumming up the explosions and the steam-whistle screams, the sirens, the bagpipes, the arc-welding halos and angle-grinding gongs and bells. The performance stages, like Burwell, were never very far from water, especially his beloved Thames.

Born in Ruislip, Middlesex, in 1949, Burwell was drawn from a flourishing career as a Barons Court gravedigger into the creative turmoil of Ealing College of Art, where he joined the improvisation workshops of the jazz drummer John Stevens. He also took lessons under Max Abrams. Such diversity was encouraged in the English art schools of the late Sixties.

The musician David Toop, with whom Burwell later performed in a long-running trio with the sound and visual poet Bob Cobbing, tells of Burwell's passion for the physicality of music,

especially when ripped out by lone players; one-string growlers, mavericks with a determination to be heard. He devoured influences as diverse as Bongo Joe, Black Sabbath, the Johnny Burnette Trio, Scottish pibroch, Tibetan Tantrism and Sun Ra's Solar Arkestra.

He spent the Seventies unwinding music and dislocating sound, playing alongside other great and irredeemable denizens of the experimental. His jack-in-the-box enthusiasm was never still. Even on the Leo, the fishing boat he kept moored on the Thames at Limehouse, he would constantly pick and tamper; worrying at the engine, tapping the depth gauge, tying knots, transmuting her solidity into a passable impression of The African Queen. Burwell's love for boats and adventure had been there from an early age, and when in 2000 he left London, it was for the deserted building of the Kingston Rowing Club, sheltering in the bleakness of post-industrial Hull.

Paul Burwell might have easily been found aboard the Pequod. He certainly seemed to have landed out of time and between journeys. Those who knew and worked with him could yarn all month about his shape-shifting: from bilge rat to silk-waistcoated dandy; from slicked-back rocker to Fluxus saint.

Once, we were returning from a charter into a storm, on a river trip with his friend the writer Iain Sinclair. This time, the freak wrangler Sinclair had surpassed himself and the members of the ill-assorted ship of fools were already retching long before Burwell navigated us into the shipping lanes.

By the mouth of the Thames, the boat was bucking in all directions and Burwell murmured the C word to those sheltering in the cabin's green cigarette smoke: "Capsize," he said, with the ease of somebody offering a biscuit, as if it were the mildest of possibilities. We skidded from shore to shore dropping off the anxious crew until the empty boat bobbed in the aftermath of the storm and we yawed back towards London in a subdued mist of whiskey and night. Without warning, Burwell glided the Leo into the gloom of the Rainham Marshes, where he moored her and leapt ashore.

The day was gone and the fog closed in. A chalky white bass note shivered the river and stopped the blood. Fast-lapping rhythms echoed and smouldered into a vast and unknown space. Burwell was playing the river. In fact he was playing a fleet of marooned concrete barges. Sticks in hand, jumping between their different pitches, fluttering their cadence with consummate skill. The music was eerie and solid, a combined sounding of place and dream.

There exists a BBC recording of Burwell playing on the Thames. When it was first aired, it so startled the ears of the listeners that it was asked for again and again, so that they might hear once more a resonance so perfect and so generously given. It is the sound of Burwell which endures, the drummer's flux between delicate whisper and furious vibration.

Paul Burwell was originally published in The Independent, Obituaries, 9 February 2007.
www.independent.co.uk

Ian Breakwell, prolific artist who took a multi-media approach to his observation of society

Nick Kimberley

If there was a medium available to the artist, there is a good chance that Ian Breakwell, who has died aged 62, deployed it. Painting, drawing, printmaking, photography, film, collage, video, audio-tape, slide, digital imaging and performance: all these and more were called into service, according to the needs of the work in hand.

But Breakwell was as much a verbal as a visual artist, and a large part of his creative life was taken up with the diary he kept for more than 40 years, a mere fraction of which has been published. He sought an art of recurring epiphany, to be captured either visually or verbally. A diary entry dated July 8 1973 gives the flavour: "The 18.30 train from London to Plymouth. In the dining car the fat businessman farts loudly and unexpectedly, and simultaneously by the side of the railway track, a racehorse falls down."

Breakwell was born in Derby and studied at Derby College of Art, graduating in 1964. The changes transforming the art world at the time had a no less convulsive effect on him, but while the traditional art school disciplines of painting,

drawing and printing would not contain his talents, he never turned his back on them. After college, he moved to London, first to New Cross, then to Smithfield, where he lived from 1968 to 1989. The area was less gentrified then than now, its twilit strangeness reflected in *The Walking Man Diary* (1975-78). This vast piece, part photographic image, part verbal commentary, documented sightings of a shabbily-dressed man who patrolled Smithfield on an irregular basis, sometimes disappearing for weeks before reappearing on a daily basis, only to slip away again.

Workman? Tramp? Mental patient? The point was not to find out, but simply to observe from the artist's eyrie. Voyeurism – social rather than sexual – was a preoccupation, as in the 32 panels that make up *Estate* (1971-76), one of Breakwell's largest works (it has a rare outing in the Frieze Art Fair this weekend in Regent's Park, London). Yet voyeurism is always mitigated by humour; he recently said: "The humour that I love is the morose, the deadpan, the seemingly unfunny stuff that is close to misery, but not quite."

During the 1970s Breakwell worked with the Artist Placement Group (APG), which dropped artists into government departments in the perhaps forlorn hope that their intuitions would improve the decision-making process. Breakwell's placements included the Department for Health and Social Security; under its auspices he worked in Broadmoor and Rampton hospitals. The results included a report, co-written with a group of architects, recommending top-to-bottom changes at Rampton, and a film, *The Institution* (1978), made with the singer-songwriter and artist Kevin Coyne. A diary entry recalls Breakwell's first APG visit to Rampton, which immediately stirred memories of performing there as a child-conjuror: the incongruous juxtaposition is entirely characteristic.

In the 1980s, he made a number of adaptations of his diary for Channel 4. Later he co-edited (with Paul Hammond) two important anthologies, akin to the work of *Mass Observation: Seeing in the Dark* (1990), an assemblage of hundreds of accounts of cinema-going; and *Brought to Book* (1994), which documented the myriad forms of bibliophiliac obsession. Although he had a longstanding relationship with the Anthony Reynolds Gallery in London, his keenness to develop new ways of working led to residencies with, among others, Tyne-Tees Television (1985) and Durham Cathedral (1994-95).

Works of this period included *Auditorium* (1994), a film made with composer Ron Geesin, in which we are taken to a variety show, but are only allowed to see the audience's reactions; the results are hilarious and touching. *Auditorium* is currently on show at the De La Warr pavilion, Bexhill, part of an exhibition, co-curated by Breakwell, called *Variety*, the title taken from another Breakwell/Geesin film. The pavilion itself was the setting for The Other Side (2002), in which ballroom dancers float serenely through its dreamlike architecture, to the accompaniment of a Schubert nocturne for piano trio.

Given a name like Breakwell, it is no surprise that his favoured sport was cricket, and it was as a cricketer that I got to know him. When he found his length (not an everyday occurrence), his bowling was almost unplayable; for his club, Palm Tree CC, he still holds the record for most wickets taken in a season. He tended to field at third man, the ideal position for a man who saw the world from off-centre.

A keen angler, he spent much time fishing at Rosscarbery, West Cork, developing an enviable skill in catching sea trout. He was also a devoted drinker, though rarely to the point of inebriation; almost to the last, he maintained his routine of a daily closing-time pint in his favoured local, the Rochester Castle, in Stoke Newington, north London (where he moved in the 1990s).

It was in 2004 that Breakwell was diagnosed with cancer. Typically, he responded with renewed creative energy, creating a series of works that looked unblinkingly at his condition. The resulting images are both painful and beautiful – just as the last pages of his diary will no doubt reveal not only the artist who created them, but unexpected facets of our own experience.

Breakwell is survived by his wife Felicity Sparrow, and by his mother Nancy.

Ian Breakwell, artist, born 26 May 1943; died 14 October 2005.

Ian Breakwell was originally published in the Guardain Newspaper Obituaries on 21 October 2005. www.guardian.co.uk

Why Do Men Walk Funny?

David Gale

Look at these guys in the street – why do they walk so funny? It seems to be a new thing: men under the age of 25 appear to be experiencing fundamental problems with the mechanics of ambulation. Their legs point in the wrong directions, they limp (without apparent medical cause), they shuffle, their legs are unnecessarily bent, the toe-heel relationships are shot, they are fairly slow and sometimes one leg will be used in a style unlike that deployed by the other. This isn't the rickety Dickensian London Poor, this is 21st Century white, Asian, black youth on the hoof. Ethnicity isn't the issue and neither is class – posh and middle class kids are stumbling and waddling all over the place alongside their less fortunate fellows.

Despite the concealing nature of the roomily tailored sportswear that generally denotes an absence of sport in the personal curriculum, it is plain to see that a walking crisis is afoot. Obviously these guys learned to walk at the usual time and dashed around the playground in a normal manner. Somewhere along the line the line ran out – tips for further walking were somehow missed or were not readily available. This is hard to credit – there are countless older or other guys walking in interesting ways that could be profitably studied.

Around puberty it becomes important to affect a cool gait – fashions among peers will mould the legs in any number of ways that may be awkward or transparently affected but sooner or later the walker settles for something that feels right, gradually personalises it then usually locks onto it for the duration. Film stars, pop stars and sportsmen are all handy, conventional points of reference for the novice gait builder.

This last assertion is currently debatable, however. Somehow the kids are not picking up on the diversity of available models. Certainly one thing the current gaits have in common is the appearance of wastedness. This can be taken both in the medical sense of muscular atrophy and the street sense of wiped out on drugs. Which is not to say that drugs are doing it to the kids. They are, as we all know, doing it to folk-hero Pete Doherty and he is widely admired for several of his distinguishing characteristics, one of which is a languid lope. I've

seen one or two decent attempts at this in Camden Town but it hasn't really caught on as yet; this may be due to the complex tension in the Doherty gait between that which depresses (the smack), that which elates (the smack) and what seems to be, beneath the opiate billows, the subject's chirpiness.

Most wasted gaits (the title of my next novel, as it happens) lack elation, however. This is because life for the people of the world is thin on elation at the moment. Despite the relentless, ubiquitous and hysterical spectacle of the celebrated and their divine characteristics, the following of role models requires a certain energy, the expenditure of which is inspired by expectations of reward. Can it be that some of the youth can't give a fuck, even about acquiring a gait that signifies they don't give a fuck? Perhaps the new shambling is a way of rejecting not just the current range of role models but all role models. This would be a second order of wastedness: the first is the familiar one where you simply imitate someone who is so worldly or worldweary that they don't give a damn for convention, don't care what people think, wish to communicate their indifference to the tight, focused postures of the employed, capitalised body blah blah. The second order, however, is actually an authentic one – it signals the fact that you've lost the will to imitate.

If this is so, does it indicate an emerging autonomy, a simple postponement of the rite of gait acquisition or a diminution of self-esteem sufficient to dissuade the youth even from simulating the appearance of self-esteem?

My effortless natural pessimism inclines me to the latter explanation. The business of being inspired is no longer inspiring with the result that young men in search of gait, instead of modelling themselves on a model, are reduced to an attempt to align themselves with generic maleness – a nebulous

conception that eludes capture because it is an idea bereft of forms. Where would you start?

Of course, it's not really gait that is being sought, it's some sense of certainty within the parameters of a gender. So much certainty has evaporated that the project is rudderless. In olden times, as we have observed, the novice male would either use imitation or locate a mentor. The problem now is that previously respectable roles have come to appear pantomimic. This need not mean that all role models are suddenly untrustworthy, rather that an awareness of everyday performance has reached a critical intensity in public perception. The gap between the performance and its performer is no longer an esoteric quantity – everybody can see everybody manufacturing themselves. It's not special or clever anymore. It's what you have to do.

This awareness of the business of show is enhanced by the way in which the celebrity magazines have acquired a second order level of hysteria. The first level is the one where the mags simply create hysteria in their readers. The second level sees the creators of hysteria grown hysterical themselves. So exercised are they by their circulation struggles that they fail to punctuate and correlate their stories properly. Thus we will see conflicting accounts of, say, Victoria Beckham's current weight problems (it is a problem if she either gains or loses weight) on the covers of a number of mags displayed on the same stand on the same day. This means that some of these stories are not true! If these stories are not true this means that the whole thing is a panto. We knew this anyway but we do expect a good script. When the people in charge of the script get the scenes in the wrong order or fail to spot major inconsistencies then we are nudged over a line that generally we prefer to ignore. The possibility arises that there is only script-writing and that there

is nothing that it is about. This is not the same as it being about nothing, which is acceptable – it's an aspect of a diverting charade that we are pleased not to examine too closely. If the panto actually refers to nothing then its manic episodes are not even lightweight, they are tissues drawn across a dark void.

Young men do not, of course, read celebrity mags as much as their female counterparts, so it's not the mags themselves that are making young men walk funny. Nevertheless, the hysteria of those whose job it is to spread hysteria has become unbecoming and constitutes a new development. The pilot is not drunk, he has actually left the plane. In the meantime the passengers will do the best they can. The plane is losing altitude. It will not, however, ever hit the ground.

Why Do Men Walk Funny was originally published on 14 May 2007 as part of David Gale's blog *Strength Weekly*. www.strengthweekly.com

The Live Art Almanac

What a Carry On

Performance artists Lone Twin will spend the next few days hauling a table, and anything else you give them, around the Barbican. It's about the kindness of strangers, writes **Lyn Gardner**

High up on a desolate concrete walkway at London's Barbican, two men struggle to move a table. The table is wonky and won't stand up alone; its surface is covered with planks of woods, several Thermos flasks, cups and biscuits, and a large tool bag. Hanging down from the table are plastic bags. One is filled with dust. The few passers-by who walk past the duo eye them curiously and continue on. What they don't realise is that these two men struggling with a table are performance artists. What the passers-by have just witnessed is art in the act of being created.

Spiral, which began at 8am last Saturday and ends at 7pm next Saturday, is an impossible journey through the environs of the Barbican estate, a place that has been called the ugliest complex in Britain, but also admired for its brutal concrete beauty. Over the week, Gregg Whelan and Gary Winters, who make up Lone Twin, will attempt to navigate a spiral path that takes them from the tube station to the heart of the arts centre. The problem is that the designated spiral will take them through walls, under locked doors, through the middle of offices

and through the City of London School for Girls. They are doomed to failure before they have walked a step. Oh, and there's another catch: along the way, they are asking the public to donate objects, which they will carry with them on their journey. They've already collected the table and the dust, and by next Saturday might well have acquired a three-piece suite and a fridge. Hence the tools with which they will try to fix everything together in one movable structure.

"It's a bit like a snowball gathering up everything in its path," says Winter. He sets about attempting to fix some of the wood to the sides of table and grins: "Is it live art or just bad carpentry?"

There may well be those who think they know the answer to that one, but as anyone who has ever seen any of the company's work will know, it has an ineffable sweetness as the pair undertake their chosen tasks to the bitter end in a way that makes them seem both supremely heroic and touchingly stupid. Often more Laurel and Hardy than Gilbert and George, Lone Twin's work takes the form of interventions in public spaces that change people's

relationship with that space and with each other. Sometimes the work goes unwitnessed; more often, it creates instant communities. The oddity of the circumstances in which the encounters happen adds to their potency. To that end, they have spent 18 hours walking back and forth over a bridge in Denmark hoping that other people might join them; dressed up as cowboys and spent 12 hours linedancing; and carried a heavy wooden plank in a straight line through Colchester. Often, it ends in failure. They once stood on a bridge in northern Canada for 12 hours in the freezing cold inviting people to hold their hands. Nobody did.

Whelan doesn't see that as a failure. "These attempts can go wrong, but they are still an event. The failure would be to stop because nobody is holding your hand. What we play with is possibility. We learned early on that once you've set out to do something you must stay with the primary engagement because you never know what might happen." In *Ghost Dances*, when the pair dressed as cowboys and linedanced blindfolded for 12 hours, they never imagined that those who encountered them would join in. But they did. Sometimes for hours at a time, supporting the pair as exhaustion set in and the mock heroic cowboys became fragile, broken-down figures.

"You do have to just let it happen," says Whelan. "If we took off our blindfolds and asked people to dance, it would be something entirely different. The fact that they do walk or dance with you for hours, that they recognise that we need help to get through is often very moving. The world is full of acts of kindness, and we experience them all the time. We get paid to do what we do, but the people we encounter along the way and who help us, don't. But they still do it."

"Our view has always been that if you go out into public spaces you should be positive. It is a waste of time not to look for the things that are hopeful, especially if you are engaged in an activity that is exhausting. Once, at a conference, somebody said that what we do is go out into the city and look for love. Yes, looking for love. That's what we do."

What a Carry On was originally published in the Guardian Newspaper on 13 June 2007. Copyright Guardian News & Media Ltd 2007.
www.guardian.co.uk

An Even Bigger Splash: Swimming Across London

It's hard enough crossing London by public transport or car. So why have 50 people just travelled from Tooting Bec to Hampstead Heath by, er, swimming? **Ed Caesar** dives in to find out

Fifty hardy souls in swimsuits, hats and goggles, gather at Tooting Bec Lido in south London at 5.30am. They swim one length of that lido, then at two others, 10 pools, and two lakes, and finish, 14 hours later, at Hampstead Heath Mixed Ponds in the north of the city. They are transported, between swims, by a decommissioned Routemaster bus. They are required to run through crowded streets, on a cold July day, wearing very little. Their every movement is recorded by a film crew.

These are the bare facts of *SWIm*. But they do not begin to convey the cosmic oddness of the event. This is "live art" as conceived by Amy Sharrocks, 37, an artist with an interest in Londoners' relationship with water. Last year, she created *Drift*, a piece where, over two nights, the artist invited punters to join her in a boat in a public swimming bath in Camberwell.

Next year, Sharrocks will walk on the paths of London's underground rivers – the Fleet, the Effra, the Westbourne et al – and "explore their relationship with the roads that have replaced them as passageways".

This year, it was the turn of *SWIm*, an art project inspired by John Cheever's short story "The Swimmer" – a tale of a disenchanted suburbanite swimming through his neighbour's back yards – and the ensuing film starring Burt Lancaster.

SWIm doesn't feel like art. It feels like a deranged school excursion. Still, that didn't stop 50 of us from signing up. I, at least, had the excuse of covering the story. But who were the other Speedo-clad dolts?

As it turns out, they were a collection of doctors, artists, writers, company directors, campaigners and IT geeks. They were old and young, fat and thin. They had signed up because they thought it might be "a laugh", a "journey", or a "unique opportunity". Some gloried in the term "Great British Eccentric". Some were worried their workmates might see them. But all of them loved to swim.

The toughest of these swimming nuts may have been disappointed, because *SWIm* involved very little swimming. One length each of 15 pools – including the 90m Tooting Bec Lido, Europe's largest

freshwater pool – spread over a day, is a breeze for people who could knock out 15 lengths of Tooting Bec before breakfast. But *SWIm*, as the foolhardy 50 would discover, was much more than a work-out.

We breakfasted at 5.30am on croissants and apple juice. My second croissant made a brief, haunting reappearance at 6.15am, 60m down Tooting Bec Lido. Still, 50 breakfasts and 50 swimmers arrived, intact, at the shallow end. *SWIm* had begun. What followed would become a familiar routine. Run back to the bus. Dry off. Have a natter. Stop the bus. Run down a high street. Find the pool. Swim a length. Repeat.

If you think this continual dipping would become repetitive, you'd be right – but not until well after lunch. During the morning, there was something novel, light-hearted even, about our endeavours. We visited 1930s architectural classics, such as the glorious Brockwell Lido; we ate bacon sandwiches; we scared commuters on their way to work.

There was one joyous moment at 7.15am, when a businessman in Balham was confronted by 50 semi-naked pedestrians in swimming hats outside his front door. "Hello!" said one swimmer, but the businessman didn't hear. Or, at least, he didn't want to. The only way his brain could compute what his eyes were seeing was to ignore it. And so, briefcase in hand, he lowered his head and pushed his way through the swimmers as if we were an inconvenient crowd at a Tube station.

These street-level adventures were good conversational fodder on the top deck of the bus, where the eclectic clutch of travellers exchanged stories. Michael Waldman, 50, makes television documentaries. He goes nowhere without his trunks, swims in mountain lakes in his holidays, and once backstroked across Venice's Grand Canal at

midnight for a packet of cigarettes. Waldman joined *SWIm* because he saw an advertisement in *Time Out*, and was interested in "the idea of this as a bit of art: possibly a bit wanky, but possibly rather wonderful".

"I regret the demise, and closure, of pools," he says. "I don't see this event as particularly a campaigning thing, but I do regret that politicians don't recognise the importance of swimming pools. So anything that celebrates swimming is a good thing. It's my drug. It's much more than exercise. I wouldn't call it spiritual, but it definitely lifts the spirits. In fact, I'd love to be doing more swimming today, but I understand why we can't."

Over a bacon and egg sandwich at the Brockwell Lido, Sally Goble, 41 – who, last year, swam the English Channel – says she is also sanguine about the lack of real swimming opportunities. "I joined for the event as well as the swimming," she says. "The thing I like about this, is, so often, when I've been working, I'm rushing to get to a pool before it shuts. It's half an hour there and half an hour back to get that precious 15 minutes before the pool closes. I think [*SWIm*] is a bit like that. There's loads of travelling for very short swims. It's a microcosm of my life.

"Also, I do have swimming friends, but generally I'm at work with a lot of people who aren't into swimming. It's great to be with a bunch of random people you don't know anything about, apart from they are really into swimming. We can share a passion, and that's great. It is a weird event. It's eccentric – but swimmers are quite eccentric, generally."

Sharrocks has decided, evidently, to tap into this eccentricity, when our bus parks up on the south side of Vauxhall Bridge, and we are encouraged to run across the Thames in our smalls. By now, there are some who are relishing the wackiness, and some

who are happy to go along with it to keep the peace. What MI6 must think of us as they stare down from their Lego base is anyone's guess, but a builder in Victoria make his feelings known. "Get your kit on!" he bellows. It becomes something of a bus catchphrase.

One man who has no need to get his kit on is Chris Morris (not he of Brass Eye fame), a fine physical specimen whose moustache and upright posture make him look like a Second World War fighter pilot. For Morris, an osteopath based in Reading, *SWIm* is just one momentous event in a week which included his 60th birthday and the arrival of his first grandchild.

"I've swum all my life, but more seriously over the past decade," says Morris. "I initially did it only in pools, until I went on a brilliant swimming holiday in the Greek Cyclades islands, and I thought, 'man, this is so much better than ploughing up and down a pool!' I recommend swimming to my patients, and it's well known now that cold water swimming can have excellent effects on your circulation – and I sort of practise what I preach. I fell in love with Tooting Bec Lido a few years ago. I heard about this event via their website, and I knew I had to do it."

At noon, we arrive at the ring-fenced swimming area at the Serpentine in Hyde Park. The swimmers, by now inured to the ritual humiliation of walking through public spaces dressed only in intimate apparel, have a new challenge: how to keep their mouths closed for 70m while swimming across a boating lake, while simultaneously avoiding the surly geese. Not everyone meets the challenge. After a thrash across the moss green course, there is a dash for the solitary outdoor shower to expunge the feathers and goose poo from our shivering torsos.

Afterwards, Sharrocks explains why she dragged us all out of bed for this punishment. "We're doing this for the dream of swimming London," says the artist. "And we're doing this for broader access to live art. And we're doing this for greater access to water in London. I've really loved how everyone's trepidation at the start dissipated as soon as we got into the swim, and there is this great sense of freedom."

The great sense of freedom soon melds into a great sense of lethargy, as sugar levels wane in the post-lunch period. We are now knocking out lengths of small, indoor pools, and the romance of the early, outdoor adventures has all but disappeared. We swim the Seymour Leisure Centre in Marylebone, the Portchester Centre in Bayswater, and the Jubilee Centre off the Harrow Road.

Sometimes, we stop when there are no pools. In Little Venice, the stern Irish project manager tells us we must leave the bus, just for a run along the side of the canal. We comply, but, with no designated swimming area, the trip is pointless. In a bid to infuse the jog with meaning, some decide to swim the canal. Led by Waldman, who has form with this sort of behaviour, half a dozen of the braver swimmers jump in, to discover, "six feet of dirty water, and six feet of shit." The canal-jumpers are told to take a thorough shower before their next swim.

The sequence of indoor, chlorinated baths is next interrupted in St. John's Wood, where, having just passed Lord's cricket ground, we find ourselves at a plush looking block of flats. We troop round the back of the apartments and find a swimming pool that could comfortably double as a foot-bath. Somehow, all 50 swimmers crowd in, do handstands, whoop and holler, and then leave for

the bus. It's another odd punctuation mark in an odd afternoon.

Luckily, it's the last bum note. As the sun comes out in the late afternoon we swim at Parliament Hill Lido, with its gleaming stainless steel refit, and the mossy, endangered Hampstead Heath Ponds. At the conclusion of the last swim, the overwhelming sensation is elation: not that we have overcome a mighty obstacle, but that we have contributed to an unrepeatable event. Was it art? Who knows. But we do know the answer when somebody shouts: "Anyone want another crack at Tooting?"

An Even Bigger Splash was originally printed in the Independent, 16 July 2007.
www.independent.co.uk

A Brisk Walk After Midnight to Rediscover One's Own Backyard

Alex Needham

A night walk in early spring is the ideal opportunity to freeze your bollocks off, which is the uppermost thought in my mind as I wait for artists Clare Qualmann, Gail Burton and Serena Korda outside Raj News in Bethnal Green in the East End of London on an icy cold night in January. The trio take me on one of their night walks, events they've staged every couple of months for the past year. While the December 21 midwinter night walk got around thirty people participating and featured a film by KLF cohort Gimpo, tonight is a bespoke walk just laid on for me.

All the night walks follow more or less the same route, a minutely planned promenade based on the three women's usual routines (all live and work locally). An inversion of the kind of walk that points out places of interest, the three describe their walk as "an archaeology of the familiar and forgotten". Setting off at a brisk pace – the weather is too cold for dawdling – the four of us soon plunge into the badly-lit back alleys of Bethnal Green, under a shadowy railway bridge and then out into semi-derelict territory that seems to be a kind of no-man's land, an eerie gap in the city ringed by the distant lights of London's skyscraper-studded financial district.

"We became really curious about the psychology of the overlooked and unfamiliar places, perhaps a bit grotty and a bit edgy," says Burton. "And the most extreme way to experience that sensation is at night. That's the scary time; that's when everybody's told it's not safe. By the experience of walking through seemingly dangerous places in a large group and doing the walk time after time we're making the space our own."

The few people around look distinctly weird – an old biker wearing a leather jacket with a picture of the dog he's walking painted on the back; a man in a cycling mask and helmet that makes him look like a robot. A sign for a bed shop wishes its customers "happy nightmares", while a brightly lit showroom called New Events has a strange swing contraption in the window and nothing else. To me it's disorientating, but to the artists (who know this route like the proverbial back of their hand), these are also signs of gentrification, suggesting to

Qualmann, Burton and Korda that they should start walking somewhere else. "This area of London's like a chink, it's a crack in the way the city's organised," says Burton. "It's slightly abandoned and it's given us a way in. You don't have that freedom in places that are more commercialised and regulated. I can see as the area gets regenerated that those freedoms are going to gradually ebb away."

The freedom the three walkers mean is the ability to impose themselves on a seemingly inhospitable landscape – to document it, understand it, and to make it a place of play. They're obsessed with creating mythologies out of the tiniest discarded things, constructing stories not only about the characters they meet but also about minutiae they find on the walk – used chip forks, lost Gummi Bears and stray graffiti. They've recorded sounds on the route (and compiled them into a cd) ranging from "the sound of an air vent to an evangelical sermon". But they've also staged big interventions along the walk too – from musicians and a trapeze artist they've organized to perform in locations en route, to bill posters of their stories they've stuck up in the street. "The more I do the walk, the more I inhabit the place so it's totally natural to put things back into it," says Burton.

This didn't go down too well with the users of a warehouse next to the walk's scariest point, a dark footbridge over the railway line. Gimpo had organised a fire and soup for the midwinter walkers (it marks a rough halfway point), until some men charged out and asked him what the hell he was doing on their patch. Burton claims the premises may be used for a real life fight club, and tells of someone who saw a blackboard inside with a price list chalked up going from £50 for a broken leg to a fiver to be pissed on. Like the rest of the walk, the warehouse is eerily dark and quiet tonight, but while it seems completely remote from the London I know, it turns out to be only round the corner from Bethnal Green's main road. Qualmann, Burton and Korda also encourage me to find another new dimension in my experience of the city by becoming aware of specific smells on the route – laundry, baking, curry and, inevitably, urine. Qualmann says she's looking forward to the day when scientists invent a machine that can record smells, so they can capture another aspect of their wanderings.

It's been a strange and stimulating evening. As we stagger into the Approach pub, the walk's official ending, I feel like I've travelled much further than the windy backstreets of Bethnal Green – into a new and half-familiar hinterland inside my brain.

A Brisk Walk After Midnight was originally published in Fantastic Man magazine, Spring/Summer 2007. www.fantasticman.com

En Route

Daniel Gosling

I

A few years ago an artist-friend told me that another artist whose work I know had once said that all art comes from anger. We agreed that neither of us agreed with him and sat down to eat. But as I crunched through my salad I couldn't stop mulling it over in my mind: All art comes from anger.

I realised that my dispute wasn't with the statement's underlying attitude but with the specific word used to pin it down. "What if I swap *anger* for *dissatisfaction*? How would you feel about what he said then?" "Are you still thinking about that? I wondered why you were being so quiet." "Well you've been quiet too. What've you been thinking about?" "Madeleine."

II

I was standing at a crossroads in a residential area, my four companions sat on the ground. The sky above us was a wide open blue, the hot sun just short of midday. To the west in the middle distance we could see the white arch of Wembley Stadium and to the north east – actually about six metres diagonally across from us – a sign that said DOG LANE NW10, a sign that we all found amusing. I imagined giving Dog Lane as my address and the unnecessary fun I could have: "Did you say Dog Lane?" "Yep." "Bet that gets ya' some comments." "Never. You're the very first person to ever mention it."

We'd been loitering there several minutes when a car pulled up and the passenger – a young woman with deeply tanned skin, blonde-tinted brown shoulder length hair and expansive brown-tinted shades asked from its open window "Excuse me. Do you know where we are?" Our responses came all at once, a momentary scrum of "sorry don't know", "near Wembley Stadium" and "Dog Lane". She appeared to look directly at me so I looked her straight back in the shades and saw what I took to be bemusement somehow managing to creep around their edges onto the visible part of her face. How could we not know where we were? We looked quite at home hanging out there on the corner. But then again we all had little backpacks and were drinking water from bottles. But if we weren't from there then

we must have got there somehow so were we just deciding to be unhelpful in the way that people sometimes do, or worse – were we taking the piss? And if either of these was in fact the case then why were we being so apparently friendly? Clearly there was something odd about us and equally clearly the thing to do was to leave it there. As their car lurched forward across the junction she said "Good luck" then they swung a u-turn and were gone.

Moments later an old man emerged from the house next to us. As he closed the garden gate behind him he suddenly became aware of our presence and – with his attention split between where he was going and what we were doing – narrowly missed bumping into his car.

III

'*Rien ne distingue les souvenirs des autres moments: ce n'est que plus tard qu'ils se font reconnaître, à leurs cicatrices.*' Everything about this often quoted text makes perfect and insightful sense to me. Except for that one word committed at the end.

When I was nine I was accompanying my nan while she did her cleaning at Sheffield University. A student walked up and asked "Can I cadge a ciggy, Hilda?" "Go on then" she said, "but don't tell others 'else th' shall all be askin' me." It was December, and the night-backed windows reflected the room in strip-lit darkened detail confused with the specks of lights scattered across a distant hill.

IV

Who were we and what were we doing at the Dog Lane crossroads that hot day in May? At the time if anyone had actually asked me I'd have said something factual like "We're walkers walking outwards from Parliament Square and we're having a little rest." But facts are one thing, truth quite

another. Because the truth of what we were doing that day is that we were searching for something without ever asking what it was. But now I know that for me it was this, these memories transformed as they're fixed into words.

En Route was written in response to the DIY4: 2007 workshop *Places We've Never Been*, June 2007, led by Daniel Gosling. DIY 4: 2007 was a collaboration between the Live Art Development Agency, Artsadmin, and New Work Network, and was developed with Nuffield Theatre/LANWest, New Work Yorkshire, Fierce! Festival, Colchester Arts Centre, The Basement Arts Production South East, and Dance4.
www.danielgosling.com
www.thisisLiveArt.co.uk

Judith Knight & Ritsaert ten Cate

Kate Tyndall

Judith Knight and Ritsaert ten Cate first met in 1980, when Artsadmin artists Mike Figgis and Hesitate & Demonstrate were invited to the Mickery Theatre in Amsterdam. Ritsaert ten Cate was the creator and director of the Mickery, an extraordinary centre of energy in international theatre, one of the most influential producers and presenters of contemporary theatre of its generation. Judith Knight was setting out, with her colleague Seonaid Stewart, to make a go of their idea, Artsadmin, to produce the work of artists they were passionate about.

'Looking back, it seems like another world,' says Judith Knight. 'LIFT (London International Festival of Theatre) hadn't yet started, there was nothing like BITE at the Barbican and apart from a few international companies coming to the ICA, the link between UK and international contemporary work, or between the 'experimental' and the 'mainstream', was almost non-existent. There were fantastic companies like Joint Stock at the Royal Court and Riverside, and at the Oval and the ICA there were

companies like the People Show and Pip Simmons, but the two didn't really mix. The more experimental work was not really taken seriously. Seonaid and I had been working at Oval House, and had come across many of these experimental companies. We loved what they were doing, and decided to work with them to produce their work and to try to increase their profile in the UK.'

The Mickery had been in existence for some 15 years, moved from the farmhouse outside Amsterdam where Ritsaert ten Cate had originally established it, into the converted cinema in Amsterdam which remained its home until 1991, when the Mickery closed after an extraordinary 25 years that had changed the international theatrical landscape for ever. 'I had heard of the Mickery when I was at the Oval House, Pip Simmons' Theatre Group was already legendary, and I knew that much of its success internationally was because the Mickery had programmed the company in its early days. Mickery was a sort of gateway into mainland Europe. Very few international programmers ever

came to London to see work; London was just not on the international scene.'

The Mickery introduced Judith to 'what was really going on in Europe'. She realised that 'the work we were producing was "serious" and valued, and that Artsadmin as an organisation – pretty much ignored in the UK – could be an important resource. We saw for the first time that what we were doing might be significant.'

Forged around a shared interest in the artists that Artsadmin had chosen to work with, a close professional alliance and personal friendship developed between Judith and Ritsaert. Many of the UK artists that Ritsaert commissioned and coproduced were managed by Artsadmin, and an extraordinary string of collaborations through to 1991 resulted: among them, Mike Figgis' *Redheugh* and *Slow Fade*, Pip Simmons' *The Ballista*, Impact Theatre Cooperative's *Carrier Frequency*, Station House Opera's *The Bastille Dances, Cuckoo*, and *Black Works*, and *Fairground 84*, a collaboration between the Mickery, Chapter in Cardiff, the ICA in London and the Traverse in Edinburgh.

At one level, the relationship with Ritsaert proved a means of survival. 'Artsadmin, and of course our artists, were on a knife-edge. The companies paid us tiny fees out of their tiny budgets, and when they earned marginally more abroad, so did we. The Mickery "gateway" led to performances around Europe, paying the artists more than they could ever earn in the UK. It helped us all cling on.'

But more importantly, the Ritsaert connection offered a commitment that the artists received nowhere else, and to Artsadmin a source of inspiration and affirmation. Pip Simmons has said of Ritsaert: 'Ritsaert made it possible for us to experiment. He was learning with us, and he didn't hide it...I did my best work there in Holland, and Ritsaert stimulated it. His stimulation wasn't just for one short period, though. He provided the best stimulation, because he stuck with you through failures as well as successes. He can't be compared with anyone else in Europe.'[1]

Mike Figgis, in his introduction to *Man Looking for Words*, a collection of writings by Ritsaert published in 1996, describes the impact of Ritsaert's support. The particular instance was *Redheugh*, 'an ambitious piece of performance cinema' which was Mike Figgis' first outing as a director and also his first attempt at filmmaking: 'I raised a small writing grant from the Arts Council of Great Britain, and I turned to Ritsaert for the money to stage the piece. Included in this was £5,000 to make the film. The money was forthcoming...a decision made in the light of other work I had done in the past, and in the belief that with some help I might become a more interesting artist...For myself and many others, a break like this is a life-changing moment. A moment that gives the courage to continue with a philosophy of life that is less intellectual, less protected, more vulnerable but also more potentially truthful.'[2] It was avowedly a turning point in Figgis' work as an artist.

Ritsaert explains: 'If you trust a group, if you hope that a lot will come out of it, then you have to support them, whichever way. We tried to bring groups together to work, or suggested they make productions that would develop their work in a direction I felt it would not otherwise take. I did what I felt was needed because I firmly believed it should happen, or because I needed to know what a project might look like. Sometimes the work was wonderful, other times it was terrible. But I would say to the group: I want the next production. That was our job as producers, and the best kind of confidence you can give.'

For Judith and the emergent Artsadmin, 'Ritsaert offered us an affirmation of everything we were doing. He produced and programmed work at Mickery not because it made a balanced programme or was fashionable, but because he loved it, it would challenge, it was risky, and he loved and respected the artists. In our own small way, we worked with the same ethos. He showed us that what we were trying to do was possible, not crazy.' She knows she is not alone in this: 'Many people have felt more able to follow their stories because of Ritsaert. What Ritsaert did – and who he is – has helped so many people over the years to see what they wanted to do and feel more able to do it. He gave artists status, strength and total support, and many other producers like ourselves inspiration. He had an effect not just in Holland but also internationally – and has made an enormous impact in this country.'

Many individuals active in the international contemporary theatre and performance scene of the 1970s and 1980s will confirm this. In the UK, for example, Rose Fenton and Lucy Neal took real inspiration and confidence from their relationship with Ritsaert as they set off on the path that established LIFT as a festival that would change the perspectives of British theatre for good: 'Ritsaert showed us that experimentation has its own ancestry and traditions and that there is really nothing new under the sun. Working with him meant being open to the unexpected, curious, playful, never standing still, forging unlikely alliances and generously sharing ideas or realising the ideas of others. Ritsaert showed us how the ideas and realities that theatre can express are of the most profound importance. Mischievous and patient by turns, the beams of the lighthouse he threw at us helped to illuminate the road we were on. "Ha!" he would say, "And why not?" It was incredibly comforting.'

In mainland Europe, Hugo de Greef, founder and director of Kaaitheater in Brussels through to 2001, and now Secretary General of the European Association of Festivals, speaks for others in the European producing community of the time: 'I created Kaaitheater in Brussels in 1977, and was part of a community of international promoters and presenters active at the heart of the avant-garde of 1980s and 1990s. It was a key moment in cultural Europe. I would not have been as successful without Ritsaert ten Cate. His way of working, his attitude and his artist-driven actions inspired me from the beginning. And I know that this counts not only for me, but for my whole generation. I am really sure, and with a serene conviction: without Ritsaert's work – and his stimulating personality – the contemporary performing arts scene in the Europe, in the world, would not be the same. And many essential artists would not have achieved the work they did.'

The impact of what Ritsaert has done has always been inseparable from the impact of the person he has been. He has an enigmatic, politically mature, playful and profoundly generous personality. Resolutely uncomfortable when he himself is the object of attention, he was the subject of Gary Schwarz's essay Ritsaert ten Cate now written in 1996 on the occasion of the award of the Stichting Sphinx Culture Prize to Ritsaert. Testimonies from artist collaborators, producing colleagues, staff, funders and family feed into a wonderful depiction of the man. (Ritsaert describes reading it like 'being put through a grater'.) It is a rich and complex portrait, which is a sensitive and insightful read.

As Mickery's impact quickly established itself during 1970s, Ritsaert equally became a leading figure in the international producing community. The existence of Mickery was far from stable, however, and there were several times of crisis in the theatre's funding and support. Ritsaert is reticent on these areas, believing them to be his responsibility as producer, a necessary back story to his passionate sense of the place of art in our lives. In 1996 Ritsaert spoke in the presence of the Queen at the 50th anniversary of the Federation of the Arts in Holland: 'How other than with trepidation and humility, may I give testimony to the power of art in society? How else can I possibly do this if not with my heart, my soul, and the commitment of my very life? Don't misunderstand me, it is not my life upon which this burden of proof shall fall. Rather it is a matter of the complex way in which art, unbidden and unexpected, emerges from the nooks and crannies of my life. My most basic problem is that I cannot even imagine the absence of art and, along with it, the power of art in present day and future society. Art is in our own interest: art is self-interest. If we can only stumble into the realisation of its organic presence in our lives, our future will be assured.'[2]

In 1991 Ritsaert closed Mickery with *TouchTime* – a season of largely commissioned work presented around Amsterdam. 'I had realised that, after more than 7,000 performances of over 700 productions, I had reached a point where enough was enough. I knew that I could no longer be the cork on which Mickery was floating. What had provided adventure and surprise had become institutionalised, and we were weighted down by our own history and old images with which we no longer wished to work. I felt the world still needed what we were doing at Mickery, but I could no longer be the one to do it.'

It took over three years to work through what this would mean. 'I spoke to the Board, and we discussed at length what to do. We talked with three staff members to see if they wanted to kill me off, to take the Mickery and turn it into something new, but finally it did not work out like that. I decided to do TouchTime, to do what we did til our last breath, and to end Mickery with dignity and festivity. There was a mixed response to the end of Mickery. Some felt it was about time, others felt it was a great loss. For me it was wonderful to be free. It did not feel like a loss, but a chance to live the next thing. Jan Lauwers invited me to perform with Need Company. I said I am not a performer, but if you will take the risk, I will trust you.'

In 1993, Ritsaert accepted the invitation to conceive and direct an international postgraduate theatre school in Amsterdam, which he called Das Arts. 'I decided this was something I hadn't done. I thought it would be truly interesting to create a generation that, whatever they were to make, would know what they were doing and why they were doing it, come hell or thunder. The rest was bluff, because what did I know of education? This time, I told everyone I would do this job for only seven years, and I devised Das Arts with a structure that would make it hard for it to become institutionalised.' Ritsaert created a fluid modular structure with an ever-changing flow of students, mentors and tutors. True to his word, he left Das Arts in 2000.

As Ritsaert prepared for Das Arts, he wrote: 'My experience of Mickery, and my still hungry curiosity, make up most of my knowledge of education. I have always wanted something I didn't yet know, something I couldn't be expected to know before I saw it. This curiosity has largely been expressed by an acute interest in the maker and the

creator. Does active and passionate interest stimulate a student? I hope so: that's what I have to offer them.'[2]

Now Ritsaert continues to write – as he has always done – and to make his own visual art work. He is based in his studio in Amsterdam where, as he puts it, 'I laugh out loud, and am serious, about my own work and about the young artists who come to see me and are trying to determine what the hell it is they're doing.' He has always been, and remains, future-oriented. 'The past has happened, it's been done. It's wonderful to have something to stand on, and know that you have done it, but let's discuss what we are going to do, let's discuss what's happening now.' As Gary Schwarz writes in the opening sentences of his essay on Ritsaert, 'The biography of Ritsaert ten Cate clamours to be written in the present tense. Few people live as intensely as he.'

Since they first encountered the Mickery in 1980, Judith Knight and Artsadmin have been on a very different journey. At first surviving on a near subsistence budget for many years, Judith's persistent, unyielding though understated advocacy for what she and her colleagues were doing, gradually built support and backing in the UK, and the Arts Council began to fund Artsadmin itself as well as project funding the artists with whom they worked. Things remained very difficult, however. 'The support for what Artsadmin was doing was there to some degree, but the stresses and strains were huge. It was the early 1990s, there was a recession on, and it was pretty tough. I could have been near to the decision that Ritsaert took. I was wondering: how long can I do this? The toll on me and others at Artsadmin – we were such a small organisation – was enormous. I was thinking to myself, actually that's enough, we've done so many

things, the artists have produced extraordinary work but it's relentless, endless, always so hard. Is there a stopping place soon that I need to recognise?'

When Artsadmin found Toynbee Studios, however, Judith also personally found a new lease of life. 'Toynbee Studios opened up so many new possibilities for what we could do. I felt re-energised. The challenges were excitingly new. I am really proud of the first years through to 1994; we did amazing things on very little resources, so I wouldn't have stopped with any sense of failure. But finding Toynbee Studios changed everything. The opportunities are so great: the issues we face now are how not to take on too much. And from the outside world's perception it has made us a more important organisation. Bricks and mortar have made a huge difference to how Artsadmin and the significance of what we can do are seen.

'The facilities that Artsadmin are creating at Toynbee Studios are transforming what it is possible to do. At the heart of everything remains the passion for the work and the artists. "We have quite simply chosen to work with artists whose work we love, and this has given us an artistic identity. What I feared might have been a bit idealistic in the early years has paid off in the longer term.'

This clear value system, clarity of artistic judgement, and steadfast commitment to the artist have in the end proved to be the secret to Artsadmin's sustainability, provided the source of its international respect, and created the soul that will ensure Artsadmin's healthy survival once Judith and her other lead collaborator, her co-director Gill Lloyd, have handed the whole story on to a younger generation.

About Judith herself, Ritsaert says: 'What you see is what you get is usually a pretty good deal. With Judith, you get a lot more. Very little you see.

So much more you notice once she's part of the deal. A quiet tenacity, great care for details, insight into the bigger picture, patience, a laid-back humour, an easygoing international network that turns out to be impressive. She'll always be there longer than you sometimes think is humanly possible, taking a warm and intelligent interest in what you aim for – whether you are an artist or a presenter. In short: a dream of a creative producer, but beware when she gets tight-lipped!' And of Artsadmin: 'At the earliest point of our collaboration, I asked what else Artsadmin did, other than make the bill higher. As I said: earliest beginnings. But soon I saw that Artsadmin saved us all money and problems, and more importantly supported the artist in their lonely quest to get their thing rolling. This is what was really important, and cannot be stressed strongly enough. Artsadmin is the embodiment of what creative producing can be. Ask the artists they serve.'

Helen Marriage, whose first proper job in 1984 was with Artsadmin to work on a project commissioned by Ritsaert, agrees. 'Judith's a mentor and an inspiration, always working on instinct and a deeply felt sense of principle. She works from an uncompromising inner truth, both serious and delighting in the witty and absurd. I'm sure the stable of artists that she's striven for know that they owe her for her unswerving support over the years.'

Graeme Miller, who visited Mickery in 1985 as an Artsadmin artist and member of Impact Theatre Cooperative, and has remained with Artsadmin to make his own work, concurs. 'There is a culture created by Judith and her colleagues at Artsadmin of being there, both in a wide sense and also in a real sense. To an artist, it's a kind of investment that makes you want to turn in work that will pay that back – work that will make the most of who you are, what you can do in your own village, in your own time. I'd say that Artsadmin has almost led with this tacit ideal of activism, born of the socially-engaged, aesthetically uncompromised work of the 1970s from which it sprang. If it could turn faxing, phoning, booking, finding the cash, into a form of engagement, then we as artists had better get engaged too.'

Artists Leslie Hill and Helen Paris of Curious originally received an Artsadmin bursary, and are now produced fully by Artsadmin, are clear what it is that makes the difference. The building offers 'amazing facilities and first-class support to artists for their ideas, processes and performances. But the support and commitment that Artsadmin gives to artists and arts practice exist with or without a great building. The place existed before the space. Its true foundations lie in the passion and energy of the people who have run it for over 25 years. Judith Knight and Gill Lloyd share an unswerving belief in the necessity of art.'

Bobby Baker values the 'active symbiosis between artist and producer' that she has with Artsadmin. 'Jude and Artsadmin work with artists who chose not to fit into traditional art forms, categories that we chose not to be part of for aesthetic or ethical reasons. That is the very point of our work, to be on the outside. Jude and her team have created a radically new way of working as producers, administrators, managers and collaborators to help us make this work. They offer us vision, intelligence, unconditional support, and an ethical, socially-minded approach. It's about our long-term development, and the endless, relentless hard work. There is a shared sense of never giving up when it's a good idea – one of Jude's strongest characteristics. And she has an unclouded and unsentimental view of artwork, an invigorating ability to speak her mind about what she sees. And

she sees a lot. People like her have been battling for years to make others see what is possible, and without posturing and hype. Artsadmin have created something that is a sensational international success. I understand her eruptions of frustration that this could have happened years ago if people had just listened. People should listen more.'

By drawing on the passion for the necessity of art that they share, and a sense of self that puts the need to take responsibility for this first, Ritsaert and Judith have changed their landscapes permanently, through the work they have helped artists to create and through the physical or institutional structures they have created to do so. And they have pursued the need to take action through the real time sweep of their lives. For over 40 years, Ritsaert has been a transformative presence in the theatre world of Europe. Now nearly 30 years after Judith first had the idea of Artsadmin, she and Artsadmin are emerging into a quiet, authoritative kind of leadership that she might have never before imagined.

Ritsaert decided to dematerialise the structure that he created at Mickery, because it was the right thing to do, and in doing so did not detract from what he had achieved. With equal validity, Judith and her colleagues have created a new permanent infrastructure that will remain dynamic far beyond their own contributions. The structures have come, and some of them have gone, but it is the people that have created their purpose and meaning, given them a soul.

At Ritsaert's final Diploma Ceremony for the students at Das Arts in 1999, he gave a speech, saying: 'That's the world we work in. And although we do not at every turn have to be aware of all of its horrors, a sense of it we must have. And when we have it, that sense, we will also be able to note how much love is needed to cope with it. You simply cannot function without it. Without love, we cannot do, we cannot be.' He signed off to his students for the last time: 'A warm embrace, with endless possibilities. Thank you.'

Notes
1. Quoted from *Ritsaert ten Cate now* by Gary Schwarz
2. Quoted from *Man Looking for Words* by Ritsaert ten Cate

Judith Knight and Ritsaert ten Cate originally appeared in *The Producers: Alchemists of the Impossible* published by Arts Council England and the Jerwood Charitable Foundation, 2007.
www.the-producers.org

I Can See Your Ideology Moving

Sally O'Reilly and **Ian Saville**

The scene: A windy seaside town in England. An arts festival (entitled, perhaps pretentiously, The Windy Seaside Town Biennale) is in full swing. An audience of skeptical locals, theater-seat-radicals and bloodthirsty performance-art lovers, sated after fish and chips and lashings of warm ale, is watching a man speaking to a picture of Karl Marx. More unusually, the picture speaks back to the man, for this is Ian Saville, socialist magician and ventriloquist, demonstrating his revolutionary art.

At the back of the hall, the art critic Sally O'Reilly watches curiously, almost unable to contain the questions that crowd her mind. The audience is laughing …

IAN: Hello, Karl Marx.

MARX: Hello.

IAN: How are you?

MARX: Not too bad.

IAN: Are you enjoying the show?

MARX: I'm enjoying it immensely.

IAN: Actually, Karl, I was just wondering …

MARX: Yes?

IAN: If in your day …

MARX: In my day, yes?

IAN: … whether you ever had anything like this.

MARX: In what way?

IAN: Well, I wondered if you ever had this sort of socialist culture – socialist songs, music, humor, or even socialist conjuring tricks?

MARX: We had socialist culture, of course.

IAN: You did?

MARX: Oh yes. We had socialist songs, music, humor. All that sort of thing. But we didn't have socialist conjuring tricks.

IAN: You didn't?

MARX: No, although it's a little-known fact that originally I wanted my theories done as conjuring tricks.

IAN: Did you really?

MARX: Oh, yes.

IAN: What was it that stopped you from doing your theories as conjuring tricks, then?

MARX: Engels.

IAN: Friedrich Engels, your collaborator.

MARX: Yes.

IAN: In what way did he stop you?

MARX: Well, I used to come home after a hard day at the British Museum ...

IAN: Yes.

MARX: ... and I'd go into my house. Through the door, of course.

IAN: Yes.

MARX: And I'd go into the living room, and I'd say, "Engels." (Pause. Louder:) "Engels!" (Pause. Louder:) "ENGELS!!" (Pause:) Because he didn't live at my house.

IAN: Didn't he?

MARX: No. He lived in Manchester, and I was in London. So I'd write to him, and in the letter I'd say: "Look here Engels, I've discovered this important new principle. We've got to get it out to the general public somehow. What about this idea – what about bringing it out as a *rope trick*?

IAN: And what would his reaction be to that suggestion?

MARX: He'd say something like: "No!"

IAN: He was against the idea, was he?

MARX: He'd say, "No! Bring it out as *Capital Volume I*, or *Theories of Surplus Value*, or *The Grundrisse*, or *Economic and Philosophical Manuscripts* ..."

IAN: In other words, bring it out as a *book*. He was telling you to bring out your theories as a *book*.

MARX: Yes. Actually, I was trying to avoid that word. For your sake.

IAN: Anyway, I'm glad you didn't bring out your theories as magic tricks, because I don't think you could explore the level of complexity in a rope trick that you could in three volumes of *Capital* ...

MARX: Yes, I've noticed that with your tricks.

IAN: Is there anything else you'd like to suggest to help me with my socialist magic tricks?

MARX: I'd like to say that "all previous magicians have only interpreted the world. The point, however, is to change it."

IAN: And I'm sure these people will change it. Though not immediately, of course. You see, this show is so effective that sometimes, when I say, "Change the world," people immediately want to get out there and change things. So they leave. Sometimes even before the show is over. But you can wait till the end. Because you probably won't be able to get much changed this evening. And tomorrow's the weekend. But anyway. Are there any other constructive criticisms you could offer me, Karl?

MARX: Well, what I've noticed is that you've only dealt with a small part of the picture. I know you've done something about class and solidarity, but there's a whole world of ideas and emotions to be tackled with this socialist conjuring business. I mean, for example, you haven't mentioned anything about surplus value.

IAN: No, I haven't. I'll get onto that straight away.

SALLY: (*from audience*): Just a minute!

IAN: Excuse me, I'm trying to get on with a show here.

SALLY: I don't think so. In fact, this is a reconstruction in written form of something that only properly exists as a piece of live performance.

IAN: That's one of the most pathetic heckles I've come across in a long time.

SALLY: It's not a heckle. It's part of a critical commentary.

IAN: Isn't that the same thing?

SALLY: No, criticality takes a position of reciprocity and exegesis in relation to the artwork, not disruption or negation.

IAN: I'm not sure I understand a word you're saying.

SALLY: You don't have to understand. This is for the readers.

IAN: The audience.

SALLY: Never mind. What I want to know is: Why are you using magic tricks in this way? Do you seriously believe that illusions such as these can change the world?

IAN: Pardon?

SALLY: (Louder) MAGIC TRICKS – WHY? A SERIOUS ATTEMPT TO …

IAN: Listen, comrade, rather than shouting your remarks from the back of this smoke-filled room, perhaps you could join me up here on the stage.

(Sally steps up. Enthusiastic applause from the now nonexistent audience.)

IAN: Thank you. And your name is …?

SALLY: Sally O'Reilly.

IAN: Do you mind if I call you Rosa Luxemburg, just for the purposes of this next trick?

SALLY: Yes.

IAN: What about Emma Goldman?

SALLY: Better, but I'd still prefer to stick to the name I was born with.

IAN: I don't know whether to interpret this as bourgeois individualism or a commendable refusal to go along with the petty demands of authority.

SALLY: Will you just get on with the trick?

(A muffled voice is heard from a suitcase onstage. It seems to be saying: "I am not actually here, but let me out nevertheless." Ian opens the suitcase and removes a Bertolt Brecht ventriloquial doll.)

BRECHT: She's absolutely right. Get on with the trick. Never mind all this theoretical stuff. Doing something in the real world, that's what's important. The truth is concrete.

MARX: Yes, you must engage in praxis – the seamless fusion of theoretical and practical activity in order to maximize your effectiveness for change.

BRECHT: And while you're at it, you could engage in a bit more practice. I can still see your lips move every time you say my name.

IAN: Listen, how am I supposed to engage in anything when I've got three ventriloquial figures continuously commenting on what I'm doing.

SALLY: Just a minute, I'm not a ventriloquial figure.

IAN: You could have fooled me.

SALLY: I'm just a writer who is complicit in the contingent construction of this narrative progression.

IAN: Never mind that. Listen here, Marx and Brecht. The reason I'm doing magic tricks …

SALLY: Oh yes, I wanted to know about that too …

IAN: … is precisely because magic is an engagement with real objects in the real

world, a sphere of performance in which the audience is constantly invited to ask themselves about what has really happened. They don't see a symbolic representation of reality, but an actual manipulation of *things* …

SALLY: Ah, but the *things* are not, in reality, behaving in the way you lead the audience to think they are …

MARX: That's right. You are engaged in illusion.

SALLY: Which must tend to weaken your audience's ability to deal with the problems of power, exploitation, and oppression that you try to expose. And anyway, these objects you manipulate are symbolic representations – they are not the real working class or a factory owner. You are dallying in the idle sport of allegory. Why don't you demonstrate your intentions instead of merely illustrating them?

BRECHT: Wait a minute. Allow me to jump to the sap's defense – on your first point, at least. The rest is too incoherent to deal with. There is a big difference between the sort of illusion practiced by the White House or Tony Blair, where the fact of the illusion is itself covered up, and what he is doing, which is an honest display of something we know to be a trick.

IAN: Exactly. We're dealing here with known unknowns, rather than unknown unknowns, to quote someone or other … And by displaying the trick honestly, the audience's consciousness of the changeability of the world is reinforced.

BRECHT: I wouldn't necessarily go that far. Anyway, will you get on with the trick?

This contingently complicit writer is getting more anxious about the direction of this narrative progression by the minute.

IAN: OK. I'll do the trick. This is a daring exposé of the workings of the money system. But in order to do it properly, I'll need to borrow a certain amount of capital. Do you, by any chance, have a banknote upon your person?

SALLY: A what?

IAN: A twenty pound note, or perhaps a fifty dollar bill …

SALLY: Sorry mate, I'm broke, skint, brassic, stymied, impecunious, strapped, a bit short, subject to the falling rate of profit. The buying power of the proletariat's gone down, as Bob Dylan has pointed out.

IAN: If you don't have the money, I can't do the trick.

SALLY: That's OK. Given that this is actually a piece of writing, the mere mention of the money serves as a commentary on the role of the writer as producer of an exchangeable commodity, a notion which tends to be overlooked by the reader imagining a disembodied apractic authorial voice …

IAN: Apractic? Is that a real word?

SALLY: No, I just made it up, as you can see from the spell checker. I like making up words that are soundiferous of sense – it keeps language alive, if a little strangulated in the ears of others. Anyway, here is my hard-earned, but in this context merely notional, £20 note.

IAN: Thank you. Could you just sign your name across the Queen's head there, thus defacing the note and adding some individuality to it.

(*She signs the note. Ian puts down the Marx and Brecht figures.*)

IAN: Now: what is money?

SALLY: Well, erm …

IAN: That's all right, it's a rhetorical question, so you don't need to answer. But since we have Karl Marx here, let's have his take on the matter.

MARX: (*Now speaking without moving his lips, since Ian's hands are nowhere near Marx's mouth controls*) Well, as I see it, money is not a thing in itself. It's a relationship between people.

IAN: As can be seen by the fact that the relationship between me and Sally has gone into steep decline from the moment I asked her for her money.

SALLY: I wouldn't say that. I am now much more intensely interested in what you are about to do. That can only deepen our relations, so to speak. Depth is not always a decline.

IAN: That may be, but you've just talked over a laugh. OK, so money determines the relations between people in capitalist society, and despite the many changes in the world since Karl Marx's days, despite the growth of the Internet, the advent of modernism, postmodernism, and hair extensions, that fact is as true today as it was in 1844 …

MARX: When I wrote *Economic and Philosophical Manuscripts*.

IAN: Precisely. But to return to this banknote; it also has a material dimension. Although the money itself is a relationship between people, that relationship is located at this precise moment in the symbolic reality of this piece of paper, an object which can be manipulated and reformed like any other matter. And paper has particular qualities. Did you know that it's possible to fold paper twelve times, if you're very careful about the direction of folding; but the point is that there is a limit. And I am going to fold your banknote just four times, since I don't want to incorporate any element of danger into this act.

(*He does so, while saying:*) Mass-action-for-a-radical-transformation-of-society-from-a-society-based-primarily-on-profit-to-a-society-based-on-human-need.

SALLY: Blimey, whatever happened to *alakazam*?

IAN: This is easier to spell. Anyway, the point is that this transformative power of money distorts the relations between people and enables exploitation to flourish unchecked in our society. Money is itself a trick, and if you could see its real nature, it would be something like this:

(*He unfolds the note, to find that it is now transformed into a piece of paper with, on one side, the word "MONEY," and, on the other, the half equation "= oppression and exploitation." He hands the transformed note to Sally.*)

Now, if I were a bourgeois magician, I'd change that back into a £20 note. But as I'm a socialist magician, I'll leave you with something much more valuable – a use value where before you had only an exchange value …

SALLY: But I'm well aware that by the end of this trick you are going to find my signed note in a sealed envelope in your zipped-up wallet, because it wouldn't be acceptable in our money-based society for you really to confiscate the property of a member of the audience.

IAN: True enough.

SALLY: So have you really changed anything with your little allegory?

IAN: I don't actually expect to be able to bring an end to exploitation with a magic act. I do expect to make people laugh.

SALLY: And is a laughing audience a prefigurement of a potential non-exploitative society?

IAN: No, it's a roomful of laughing people.

Sally O'Reilly is a London-based writer, lecturer, producer of performance based events, and founder of the Brown Mountain College.
Ian Saville has been performing his "magic for socialism" act for the past twenty-five years. He is also an actor and teacher, and has written a Ph.D. dissertation on the history of the British Workers' Theatre Movement. He works with Forum theatre group Arc, and teaches part-time at Middlesex University, London.
I Can See Your Ideology Moving was originally published in Cabinet, Issue 26, Summer 2007.
www.cabinetmagazine.org

The Document Performance

Rebecca Schneider

As a performance theorist and theatre historian, I have been engaged for a long time in thinking not only about theatricality and its composition in repetition, but about that vexed category of the 'live' as a descriptor of performance – one often used to distinguish theatre or performance art from other media, such as photography. Recently, I've been engaged in trying to *unthink* some of our long-sedimented distinctions between medial forms (such as between performance and photography) as I have been suspect of the category of the 'live' to the degree that it pretends to delimit a present moment to instantaneity. I have also been suspect of the habit of the category of the 'live' to reify a supposed antithesis: very often posited as the object, the remains, the trace, or death. Supposedly, a photograph is always already a record, as it appears to survive something that can be called the 'live' event – standing in as a trace or document of something that 'was there' (as Barthes would have it) but 'is' no longer. Does this way of thinking about photography limit our access to a photograph as event – as a performance of duration – taking place

'live' in an ongoing scene of circulation, re-circulation, encounter, re-encounter, and collaborative exchange with viewers, reviewers, reenactors, re-performers, re-photographers?

It may be that thinking about performance as taking place only in a linear and disappearing present limits our thinking in significant ways. Why can a performance not take place *as* a photograph? We are habituated, for example, to thinking of the 'present' as singular, unfolding in a linear temporality that is, to my mind, problematic. Given my trouble with linear time, I have been very interested in the fact that theatricality demands a simultaneity of temporal registers – the always at least 'double' aspect of the theatrical, about which Gertrude Stein remarked that the "endless trouble" of theatre is its syncopated time. To this end I have been looking for what Homi K. Bhabha has termed "temporal lag", and which Elizabeth Freeman has spun to "temporal drag." These tropes have lately afforded me a productive set of tools to apply to the effort to articulate the longstanding *interinanimation* of live media (such as performance) with media of

capture, or media-resulting documents or objects or images (such as photography).

A word on the word interinanimation – John Donne used the word "interinanimates" in his love poem, *The Exstasie*, referring to live lovers, lying still as stone statues while their souls intertwine, redouble and multiply. I. A. Richards, the architect of New Criticism, expropriated the term and applied it to poetic "attitudes" (interestingly, also a nineteenth-century term for tableaux vivants). Fred Moten has recently used the term to suggest the ways live and media of mechanical and technological reproduction, such as photography, cross-identify, and, more radically, cross-constitute and "improvise" each other. All three senses reverberate in the collaborative work of Manuel Vason with Live Art performers.

There are a number of ways in which Vason and his collaborators' images disrupt the reign of the uni-ocular perspective of the camera. The simplest way is that the pieces are hailed as 'collaborative'. As collaborations between live artist and photographer, Vason's pieces are arguably both photograph and performance – asking us to engage a photograph not only as the record of a performance, but *as the performance itself*. This raises tantalizing questions about the duration of performance; about the limits or limitlessness of liveness; and about the trajectory of a scene into its playing and replaying across hands and eyes that encounter it *still* in circulation.

While Vason is hardly the first photographer to engage in and with theatricality or performance (think of Nadar's Pierrot series or Bayard's staged suicide) Vason's outright articulation of the image itself as collaborative performance unsettles the singularity and uni-ocular perspective habitually laminated onto the photographic scene. In this way, Vason and his collaborators invite an end to the longstanding animosity between live performance and its visual documents – twin only to the longstanding antitheatricality of the visual art establishment (let Michael Fried stand as only the most famous exemplar[4]). If we are familiar with art history's antitheatricality, we might want to be reminded that the stream has flown both ways. Consider the following from theatre historian Barbara Hodgdon in 2003:

> [The theatrical still is] the visible remains of what is no longer visible, a fragment that *steals* theater, stills it – and dis-stills it. […] the theater photograph undertakes a visual conversation with performance: silent, impoverished, partial, it *seizes* appearances, *violently severs* them from their original context; inseparable from and traversed by the lived experience of theater, it requires anecdote, narrative, to supplement it.[1]

Even where artists are not as suspicious of photography as Hodgdon is, the photograph in relation to performance is usually approached as ancillary, documentary, or evidentiary. Unlike Hodgdon's theatre artists, performance artists or Live Art practitioners rely, rather, on photography to document a work when there is no script to precede the event. If theatre's privileged document has largely been the precedent texted play, Live Art's legacy for the archive has generally been the documentary photographs and narrative accounts that appear to follow in the wake of an act. Still, in most instances of Live Art, the photograph is a supplement, a stand-in for the event itself, or an instance of its traces or detritus. In such cases the photograph is usually given to say: This is what you missed, and thus this image stands as strange proof that you, viewer, were not there (even if you were).

That is, the documentary photograph intones: You will have missed this (even if you were in attendance). It sings of remove, not inter(in)animation. Or at least, this is what we habitually hear, how we are conditioned to attend Live Art documentation.

Clearly, Vason and his collaborators suggest something difference, inviting another approach. In the spirit of that difference, I have composed a letter. I hope that this letter will resonate – suggestive, I hope, of alternate routes in thinking *between* media, *among* media, and *beside* media: live, re-live, un-live, post-live, pre-live, and otherwise *inter(in)animate*.

1. Barbara Hodgdon, 'Photography, Theater, Mnemonics; or, Thirteen Ways of Looking at a Still', *Theorizing Practice: Redefining Theatre History*, eds. W.B. Worthen and Peter Holland, London: Palgrave McMillan, 2003, 89.

Dear Collaborators,

You may have to excuse me. Pardon me. I don't mean to jostle, to push in here, to chime, but I seem to want to say: I am here too. Remember. I am collaborating. I was there and will be there in the future of the event that is even now *still* taking place: the document as performance as document. Now. *Still.* Live. Still … taking place. *In someone's hands.* I was there *in the future*. Me – spectator: event attendee.

I am asking now: where are we? Across how many times and how many spaces can the live withstand its passing? In and through how many hands? How many responses to how many calls? What are the borders delimiting our collaboration, policing our duration? Or can we be done with borders? Document days, archive haze: glossy page in hand in-handedness, reddening to the touch. Whitening. Blackening. Where will we all have been? In the ongoing reverberation, repetition: Document as invitation, script – pre-live, live: Make something together: collaborate.

Pierce me with feathers. Flay me with feathers. "Fly."

Instruction. Invitation. Interinanimation. We make something together. We choose to turn the page for example. Or dwell. Egg as hard as rock, flesh as glossy as flour, cut as deep as milk. Bricks and windows. back lot dirt, table leg. Theatres of this book in circulation. Passing. Blood muscle ink. Eye make then, and then again, now.

Maybe it's always been this way: collaboration.

Still: citing collaboration, *calling* collaboration, casting collaboration beyond singular sight invites less a "new" media, less a even a "new" image or look than an alternate way of reading, an alternate siting of the event, an alternate account of what

takes place (and where and when) that pushes any
event or any seemingly singular *thing* off of itself
and into a mobile space, a transient space, a creative
space, a future space as it is always more than one –
it is always *between.* Inter(in)animate. So I like to
think of these images less as the *result* of
collaboration than as, themselves, collaborative.
How? Because, made by performers as a
photograph, and made by a photographer as
performance, YOU are attending the performance of
the document. Thus, spectator, as audience member,
YOU attend the performance, which is to say, you
make it a performance.

The Document Performance.

Who is not involved? When?

Live is a call, weary of linear time, calling:
Cross.

Love,
Collaborator

The Document Performance originally appeared in
Encounters: Performance, Photography, Collaboration (Johnson,
Dominic ed) published by Arnolfini, 2007. The publication
accompanied *Encounters* – an exhibition of photographic
collaborations between Manuel Vason and various artists.
www.arnolfini.org.uk

Review: Francesca Steele, *Pulse*

Rachel Lois Clapham

I put my name down on the list and got a date with you. As simple as that. You and I one to one from 2.50 to 3pm. At 2.48 I was asked to leave my bags outside, take my scarf off. Evidently there was going to be close contact of some kind with you. Our touching, it seemed, was to be inevitable.

Inside the room was dark. You faced the wall at the far side. Naked and ample. Your back was turned. There was no face to greet me. No welcome. No signal on what to do or what you were thinking. Your turning away, your bare neck and the back of your head with no face, puts full responsibility on me – the participant – to act. This puts you at risk and leaves you subject to violence. In turn, this makes me uncertain. I am left unsure, scared of my potential to perform an act that you and your body-with-no-face allow and legitimise, moreover invite. The power of *Pulse* is reversed: I am the vulnerable one, aware of my own capacity to do harm, whilst you are naked and in control. Meanwhile, I'm stuck on the floor between me and you, afraid to move.

After a while I cross over. Sit down in front of you, my back to your front facing the wall. You choose not to act and so do I. We are silent together. One minute. Two. Then three ... Then your arm moves slowly out across my shoulder. Only now does your face come into view. A second hand image reflected from the mirror you hold out and angle towards me. Through the mirror you look into my eyes, you look kind. Your skin is soft and we smile. You bend over and whisper close into my ear 'take the mirror'. Was this prompt scripted or something special between you and me, a connection?

You place two fingers on my throat. My pulse races against them. In the mirror I see you naked, soft and defenceless yet you are still in command. You watch me watching you. Your face dares my face to look beyond it, to reflect my gaze away from your eyes and down past your chin, over your shoulder tattoo, south beyond your breast bone to piece together the parts of your front previously unseen. But your face never loses its control over mine, it wins. I am unable to look away from it. You say 'thankyou' and thats my cue to leave.

Francesca Steele, Pulse was originally published on Writing
From Live Art, 11 February 2007.
www.writingfromliveart.co.uk

Review: Helen Paris, *Vena Amoris*

Theron Schmidt

The piece begins with a call on my mobile phone while I'm waiting outside. It's Paris, telling me she's going to stay on the phone with me, and inviting me to enter the theatre. The theatre is empty, with a chair lit up in the middle of the stage. She asks me to sit in the chair. When I do, the house lights go down, the stage lights blind my view of the auditorium, Doris Day starts singing *Make Someone Happy*, and Paris starts talking about the danger of theatre. Not the moral or emotional danger, but the physical danger – the risk of fire from the gaslight of pre-electric theatres, the reservoir of water that used to hang over the stage, invisible to the audience but always at the edge of the actors' awareness, and the symbol of comfort that is the fire curtain.

Following Paris's instructions, I am led through the levels of Toynbee Hall, up its stairs, inside a fire cupboard, and at one point into a room actually called the Fire Room. I watch a film which Paris tells me was made by Thomas Edison, while she describes to me – over my mobile phone – Edison's rival Nikola Tesla's dream of free wireless energy. Alone in a room with a whirring Van de Graaff

generator, I am asked to turn off my phone and then feel the generator's electric charge with the third finger of my left hand, the finger that Paris tells me the Egyptians believed was connected directly to the heart. A beautiful woman opens a door to reveal her twin on the other side, and at the journey's end I sit before my own reflection in a dressing room mirror ringed with incandescent bulbs. And in a brief glimpse there is a moment of contact, but with little more than Paris's shadow.

The idea of the one-to-one performance seems to hold the promise of escaping from the trickery of ordinary theatre, of establishing a real and direct connection between performer and spectator. Helen Paris's *Vena Amoris* does the opposite: it immerses the spectator in exactly that theatrical trickery, that vantage from which the mechanism behind the illusion is revealed; and it defers and obscures the direct contact for which it nonetheless yearns. But in this itinerant experience, a complex relationship between the magical and the practical is developed, and the illusory becomes all the more compelling for having its workings exposed.

What is the danger of falling in love with an illusion? Does it hurt anyone to believe that the singer is singing just for me? That the sound of your voice on the phone is the same as being with you? The connections between us are fragile enough (as I found out after my phone gave out briefly); it's no wonder we mythologize the technology that connects us, even long after we're gone.

Helen Paris, Vena Amoris was originally published on Writing From Live Art, 24 June 2007.
www.writingfromliveart.co.uk

Dear Artist ... Love Audience

Helen Cole

Dear Artist

You need to meet your part of the bargain and if you do this, I promise to fulfil mine. I know these demands are difficult, but for this contract between us to work, I need you to meet me half way.

When I come to see a show by you, I want to be shown things I would not have the opportunity to see anywhere else. I want to discover new possibilities that I could not find without you. I want you to be a seer and a doer, a magician, an explorer. I want you to effect change, be that large or small. I want you to understand why you have invited me here, to be aware of my presence and what I am offering in return. I want you to be curious and fearless, humble and questioning. I want you to be a bit impressive, strange and special, clever and full of charm. I want your imagination to work over time, all the time, even in your sleep. I want you to hover on the edge before plunging in. I want you to play and think and make a difference, whilst you touch and shock and amuse. I want you to be alive to risk and difficulty, incongruity, intrigue and doubt. I want you to hold a magnifying glass to uncertainty, contradiction, ambiguity, to be mobile, nomadic, dynamic, to disrupt and reshape. I want you to possess good timing, humour, skill and humility. I want you to be ordinary and extraordinary, real and unreal, familiar and wild. I want you to open up the doors between worlds and navigate the gaps in-between. I want to follow you into the dark and make my imagination fly. I know this is impossible but I want you to be all this.

In return, I will be attentive in the dark and make you aware I am there. I will react to anything you throw at me with interest, compassion and belief. I will be awake to any possibility, especially the untested and untried. I will not always seek beauty, but will look for the restless and the truth. I will allow my subconscious to be free and my senses to be alive. I will be active and open minded, questioning and fierce. I will be brave and loyal, challenging and intrigued. I will be open to your suggestions and will meet your curiosity with fearlessness and understanding. I will question you, but my mind can always change. I will bring

knowledge and experience, excitement and hope. I will be appreciative, supportive, critical, honest and clear. I will put my bum on the seat and if there is no seat I will not complain. I will follow you and match the risks you take with risks of my own. I will be generous, responsive, intelligent and pleased. I will give a standing ovation, buy you a drink, come back again and bring others too.

Is this ok? Then let's do this thing together. Thank you.

Love Audience

Dear Artist originally appeared in the Doubt Guardian, published by Guardians of Doubt.
Helen Cole is Producer: Live Art and Dance at the Arnolfini.
www.arnolfini.org.uk
www.guardiansofdoubt.org

Demolish The Theatre!

Simon Casson

To: McMaster Review Team
 Department for Culture, Media & Sport

From: Simon Casson, Producer, Duckie
 simon@duckie.co.uk

Dear Review Team,

Demolish The Theatre!

Thank you for your invitation for consultation towards the McMaster Review for James Purnell and the DCMS. The central questions – about risk taking and innovation, and the wide engagement of audiences – I have addressed in the following polemic. My input comes from a performing arts P.O.V – theatre, dance and music. My real interest is in audiences.

Quick background on me. Duckie is a collective of club runners and anti-theatre peddlers producing event culture: audience interactive new wave shows that mix pop, performance and politics for London's post-gay community. I am the founder

and producer of the company formed 12 years ago, we are a fixed term revenue funded client of Arts Council England, London, delighted to be enjoying very good support under this Labour government. We are based in a gay pub, the Royal Vauxhall Tavern, but do shows all over the place including in the past year, the Barbican, the Sydney Opera House, PS122 in New York and lots of gay scene commercial entertainment venues.

> "The urgent expression of ideas can no longer always be framed on a wall, put on a plinth or stuck safely behind a proscenium"
> (Michael Morris, Director, Artangel)

With regard to this report being headed by Brian McMaster, I will kick off by stating that Duckie are actively against the culture of the Edinburgh International Festival, especially when Brian was in charge of this. It symbolises everything that is crappy about arts funding and arts profile in the UK today. It is produced by the posh for the posh. It's Radio 3 culture and it is boringly dominant in terms

of the funded high profile arts. It is inaccessible, stuffily ridden with redundant traditions, culturally po-faced and I would like to take a baseball bat to it. Interestingly, Brian has taken a position on the board of the new Manchester International Festival. Now this is more like it. This fest is much better, it owes much to the beacon that is the Sydney Festival, it is sparky, dynamic, truly cross cultural, popularist without dumbing down, full of interesting collaborations between pop stars and other artists. It's not top down and overly posh, it is relevant and fun, punchy and very Manchester. This is unusual for a funded festival, they tend to be much more boring, just look at the farkin' Brighton festival if you wanna be bored by a bunch of toffs with a fixed idea about what 'excellence' is.

Duckie are social engineers and community entrepreneurs. It is central to our game to broker new relationships between artists and audiences. We don't just want to play to the art house crowd, the middle class arts go-er is far too dominant and too well served by the arts community, arts establishment – i.e. the big theatres, etc – and particularly by arts funding.

It is the responsibility of arts outfits to create dynamic new art for UK communities. Many arts organisations are set in their ways, ploughing out similar cultural product for similar audiences for decades. Funding can harm the arts in Britain as well as help it. There are lots of ACE funded companies that act as if they work for the council, culturally stagnant, set in their ways, paying off their mortgages and getting a fat arse.

Art is not an essential public service. Many arts practitioners, administrators and directors in our funded sector act as if they have a god given right to have continued public funding support. Theatres are not hospitals, they should not be funded and

managed in the same way. The culture of tradition and modus operandi in many of these places is a barrier towards creating a truly dynamic arts scene.

There should be many more collaborations between pop culture, music and youth culture and the theatrical establishment. There should be more theatre for young black girls, more theatre for street drinkers, more theatre for new polish immigrants – this is the lifeblood of this country, this is the cutting edge – and less theatre for ponces in white linen suits who already work in the arts. Rise to the challenge of creating a new popularist white working class theatre and provide a true community alternative for this class that can rival The X-Factor and the other commercial shit they are sold on a daily basis.

I am aware that in the creative arts – as in commercial pop music, youth culture, fashion and sport – the middle classes do not have all the answers, and usually not the best ones, just solutions palatable for their own kind.

I am glad we do not live in America with the arts having to just survive in a commercial marketplace with no public support, but am wary of the tardiness that government support often gives rise to in a planned economy.

I believe in a new community theatre.

My message is that we should break a few rules and slay a few sacred cows in order to energise the 'sector'. Art should be revolutionary – that is much the point of it, to change the world, to change how we see the world. We are not really achieving this in terms of the audience that the arts attract. The new audience that is not reached by the publicly funded sector are too busy to come to your shitty theatres – they are at home watching the soaps, reading celebrity magazines, they are busy taking drugs, getting involved in knife crime, being lonely, going

on My Space and You Tube, begging on the street, buying ice cream at 'We Will Rock You'. This is the audience in London. Why don't we put on a show for them?

Fact: Exciting art comes out of struggle. That's why the most dynamic culture is black street youth culture in London and the most dull art is produced by comfortable white people living in Brighton. The arts are a cultural hegemony and change is over due. The principals that John Maynard Keynes espoused when inventing the arts council for post-war Britain need a serious update to make them relevant to the majorities and minorities in post millennial Britain.

Theatre should take social change more seriously. Use theatre to keep people out of prison, not as the intellectual and spiritual icing on the cake for bourgeois people who already have wonderful lives. Let lottery funded theatre be made specifically for the people who buy lottery tickets.

Duckie do not attract the sort of audiences I list above. It is our long term aim, but it is very difficult to truly change a culture, so we mainly make shows for middle class gays who like a bit of fun. This doesn't stop me dreaming and scheming and seeing the bigger picture.

Here's some quick ideas about how to liven up theatre in London:

Get Trevor Nunn to make a hip hop musical with Lethal Bizzle and tons of skateboarders in Brockwell Park.

Put bingo in the Barbican and have the RSC doing the calling with fourth wall drama between the games for an audience of OAPS.

Tell Michael Clark to choreograph the youth sports teams and put them on half time during an Arsenal match at Emirates stadium.

Invest in tons of street performance, have it in every town centre, every Saturday afternoon. Do not let any current street performers produce it though, get only real artists, not Australian hippies, and circus bores. Commission all the big choreographers to make dance for shopping centres only, ban them from working at The Place, The Laban, etc.

Close down most of the 'new writing' theatres in London. There too many of them, The Bush, the Royal Court, the Soho Theatre, etc. Demolish The Gate Theatre. Bulldoze The Oval House, The Drill Hall, Jacksons Lane, etc. Use the money for something else.

Prioritise variety shows as the legacy of popular working class entertainment. Get truly talented artists to create new variety shows for council class audiences. Get Michael Barrymore to work with Robert LePage.

Get the National Theatre to do a residency at Heaven nightclub.

Dare the ENO to put on outdoor concerts in council estates on sunny Sunday mornings.

Ask Pina Bausch to work with lap dancers in Shoreditch.

Put more performance poetry on buses.

Make Simon McBurney create spectacles outside black garage and grime clubs.

I have been deliberately provocative, damning and taking a broad-brushstroke approach in my attack of the funded performing arts scene in the UK. I am doing this in order to get attention and make a clear statement. The truth is obviously more complex than this, but a more thorough assessment of the arts is not required from me – bullets and fireworks are more appropriate in this short dispatch from post-queer south London. I am aware that it reads like a Trotskyite rant, and I may come across as a nutcase, but it is written not without humour. I believe that radicalism is missing in the arts

currently in the UK. The funding structure of regional theatres and arts centres was a moment in time – invented post war for the second half of the 20th century, it doesn't have to always be this way.

Come on Arts Council, Demolish the Theatre! It's only by breaking it down can we see what we truly have and what the future might be.

Demolish The Theatre! was originally written in response to a letter from the McMaster Review Team, Department for Culture, Media & Sport. www.duckie.co.uk

The Live Art Almanac is a Live Art UK initiative, published by the Live Art Development Agency and financially assisted by the University of Leeds.

Live Art UK's *Into Action* programme (2006 - 2008) has been financially assisted by Arts Council England.

www.liveartuk.org
www.thisisLiveArt.co.uk
www.thisisUnbound.co.uk

Editor, Daniel Brine.
Live Art UK coordinator and The Live Art Almanac managing editor, Emmy Minton.

First published 2008.

ISBN: 978 0 9546040 6 6

Live Art UK brings together key promoters and facilitators to support and develop the Live Art infrastructure for the benefit of artists and audiences.

The Live Art UK network explores new models for the promotion of Live Art; develops new ways to increase the national and international visibility of Live Art; and initiates strategies for a more sustainable future for Live Art practitioners and promoters.

Live Art UK aims to provide a representative voice for the Live Art sector in the UK and act as a point of contact for promoters wishing to engage with Live Art in the UK.

Live Art UK partners:
Arnolfini: www.arnolfini.org.uk
Artsadmin: www.artsadmin.co.uk
Bluecoat: www.thebluecoat.org.uk
Chapter Arts Centre: www.chapter.org
Colchester Arts Centre:
 www.colchesterartscentre.com
Fierce! Festival: www.fiercetv.co.uk
Greenroom: www.greenroomarts.org
Live Art Development Agency:
 www.thisisLiveArt.co.uk
New Work Network: www.newworknetwork.org.uk

Live Art
Development
Agency

LOTTERY FUNDED

Live Art UK

UNIVERSITY OF LEEDS

Printed in the United Kingdom by
Lightning Source UK Ltd., Milton Keynes
138715UK00002B/40/P